W9-BIQ-332

# GREAT PICTURES
## WITH YOUR
# SIMPLE CAMERA

# GREAT PICTURES
## WITH YOUR
# SIMPLE CAMERA

## Charles Gatewood

DOUBLEDAY & COMPANY, INC.  GARDEN CITY, NEW YORK

COPYRIGHT © 1982 BY NELSON DOUBLEDAY, INC.
ALL RIGHTS RESERVED
PRINTED IN THE UNITED STATES OF AMERICA
DESIGN BY JEANETTE PORTELLI
Library of Congress Cataloging in Publication Data

Gatewood, Charles
    Great pictures with your simple camera.

    Bibliography: p.
    1. Photography—Handbooks, manuals, etc.
I. Title.
TR146.G24          770          81-43600
ISBN 0-385-18526-X                 AACR2

10  9  8  7  6  5  4  3  2

# Contents

# Introduction

The future of photography is here.

With the arrival of the inexpensive pocket camera, photography is now available to just about everyone; even children can be introduced to the world of photography with today's easy-to-use equipment. Today's simple cameras have made possible the old populist ideal of "art for everyone." Except for language, there is no other medium of expression used by so many people.

The advantages of the pocket camera—small size and relatively low price —mean that you can always have a camera with you. From this point on, there is no reason to be without one at all times.

The pocket camera also challenges the common misconception in photography (one encouraged, of course, by the manufacturers of expensive equipment) that "the better the equipment, the better the picture." It is true that larger, more expensive cameras can reach certain standards in speed, magnification, and other functions which cannot be matched by pocket cameras. But short of the need for absolute perfection and professional quality, a really good pocket camera can take photographs every bit as fine as really expensive equipment. In fact, many professionals are now beginning to use pocket cameras as a second camera, and some confess to using them for 90 percent of their work.

One photographer, well known for her candid shots of people, comments, "Because I'm a woman and because I have a small, inexpensive camera, people don't take me seriously; they don't see me as a threat. So they relax and I can get shots I never would if I was carrying a big fancy instrument."

Another professional adds, "I really like pocket cameras. For one thing, I can take them anywhere. I catch a lot of shots at parties and social events where I don't want to lug my twenty-five-pound equipment bag around. And I take pocket cameras sailing or to other activities where I wouldn't risk losing an expensive camera."

I can fully understand this point of view. One night, while photographing a special party at a disco, I lost my camera bag in the crowd. Luckily, it was found and returned to the manager, who got it back to me. But I had a very difficult two hours contemplating the loss of almost two thousand dollars in cameras and accessories.

Last year nearly fifteen billion photographs were taken by Americans, most with inexpensive pocket cameras. Within a few years after they were introduced, these compact electronic marvels have affected the way tens of millions of people take photographs.

In a very short time pocket cameras have gone from being considered "novelties" to gaining status as precision instruments. And within the decade it will certainly be possible to get Leica quality with a camera that costs under fifty dollars.

The appearance of these wondrous minis is due to technology catching up with imagination. Even as early as 1840 some pioneers were predicting the invention of the pocket camera. The early photographers understood the principle of miniaturization, but the technology was not available to convert the clumsy, large accordion boxes into the trim, slim instruments we have today. In fact, pocket cameras are the logical conclusion of the major theme in the history of photography: making equipment smaller, less expensive, and of a better quality.

The first "cameras" were very large indeed. These were the *camera obscura* (Italian for "dark chamber"), or rooms that were sealed off from light except for a lens, or pinhole opening, through which an image was projected in natural colors onto an opposite surface. The image, of course, appeared upside down.

The device was very popular with both dilettantes and artists. The wealthy used it as an amusement; craftsmen used it to sharpen their drawing skills. This invention reached a height of absurdity when French aristocrats rode around the countryside in closed carriages, drinking champagne and watching the scenery reflected on a silk screen inside their lightproof chamber.

However, even though the principle of the camera was known since the Renaissance, the first person to *record* an image was Joseph Niepce in 1826. This was a photograph of rooftops taken from his window and requiring an exposure of several hours.

What is interesting about this period in relation to pocket cameras is that early photographers, now considered great masters, used equipment much cruder than any current thirty-dollar camera. The fact that the very first photographers did brilliant work with primitive equipment proves that you don't need thousands, or even hundreds, of dollars worth of machinery to take great photographs.

Cameras remained relatively unwieldy until the 1920s, when the Leica made its appearance in Germany. There had been a fad for "spy cameras" in the 1880s, but it was short-lived. These were fun gimmicks, but you couldn't take really satisfying photographs with them.

The German Leica, a compact precision camera designed to use 35mm movie film, marks the beginning of "popular" photography. The immortal photographers André Kertész and Henri Cartier-Bresson championed the 35mm camera. They were the first to take these cameras seriously and realize their true potential.

But until the early 1950s the only way to get high-quality equipment for this kind of camera was to buy a very expensive German or Japanese item and then test each lens and body carefully. Since then we have seen the introduction of cameras of comparable quality for a fraction of the cost.

There are many reasons for this happy trend. One is the continual improvement of space-age technology in general. The same thing is happening in other fields. Computers, for example, are also smaller and cheaper than earlier models, and can do a great deal more.

Another important reason is the use of computers to design lenses. Correct grinding and placement of lens components can now be worked out with great mathematical precision, allowing for higher grade lenses to be mass-produced. This ties in with breakthroughs in plastics technology, allowing for the manufacture of cheap, lightweight camera bodies.

There are pocket cameras now that are only a little larger than a pack of cigarettes, cost under a hundred dollars, and are capable of producing a top-quality photograph. There are also pocket cameras, somewhat more expensive, which feature interchangeable lenses, automatic focus, single-lens reflex viewing, and a wide variety of photographic systems.

The new Polaroid 600 even offers an electronic fill-in flash with automatic control. The photographs develop chemically in such a way that large discrepancies between dark and light spots are "evened out" so that the final print looks professionally lit.

The pocket camera is also changing our ideas about art. Art used to be judged on the "precious object" scale. The more rare something was, and the more difficult it was to create, the more it was valued.

But anyone can take a photograph; a gorilla once took its likeness in a mirror and the photograph was printed on the cover of *National Geographic!* This has led some critics to state that photography isn't, and can never be, art. But all of us have seen photographs that have moved us as much as a painting, a poem, or a piece of music. So we *know* that photography can be an art, no matter what the critics say.

The point of this book is not only to guide you in your choice of a camera and help you in using it, but to enlarge your idea of the things you can do with photography—the visionary or creative aspect of photography. Taking pictures is not only recording events and people; it is expressing ideas and feelings about them.

Now it is possible, for less than the price of a family dinner in a good restaurant, to take your place alongside the finest photographers in the world. And the pocket camera is your key.

Let's start with the basics . . .

# GREAT PICTURES
## WITH YOUR
# SIMPLE CAMERA

*part one:*
# TECHNIQUE

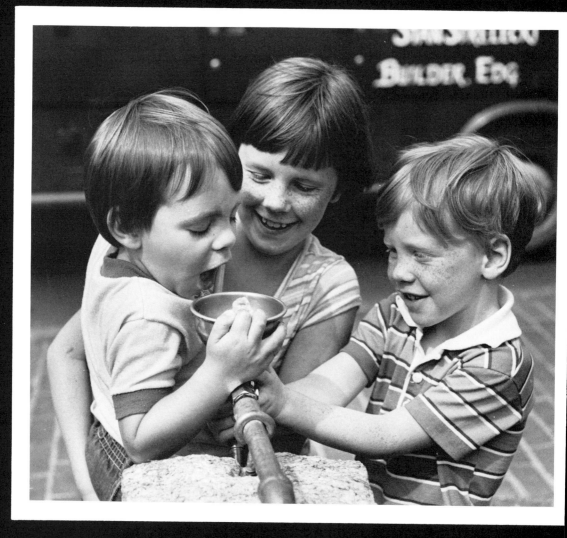

# Pocket Cameras and How They Work

All cameras are basically alike. As I pointed out in the Introduction, a camera is simply a box with a hole in one end and a sheet of film against the opposite side. Light enters the hole and falls on the film, activating the sensitized surface, thus creating an image.

Whether you own a two-dollar "toy" camera or a highly sophisticated model costing hundreds of dollars, the principle is the same. The difference in cost is due to the quality of materials used, the amount of skilled labor involved, and the number of accessories and photographic systems.

There are many things to consider in buying a camera. Most people, when asked what they want out of their camera, will reply, "To take good pictures." But often there are other motivations. Some people buy a camera as a status symbol. They just want a prestigious bit of equipment to show off. Some men buy a camera as an excuse to meet girls.

When you are considering what kind of camera to buy, you should ask yourself a number of questions. For example, do you plan to do much traveling? If so, light weight and compactness take priority. Do you have special interests in the way of subject matter? If you want to shoot wildlife, for example, a telephoto lens is a must, so you have to get a camera that has interchangeable lenses. If your thing is sports, you should have a camera with fast shutter speeds.

---

Here I used wide aperture at close range to achieve a shallow depth of field. The result is that the children are in perfect focus while the truck in the background is blurred. This photograph also points up the necessity for capturing just the right moment when shooting children.

# ◘ COST

Of course, in addition to motivation and function, you have to look at the price tag. It is the same with cameras as with everything else: You get what you pay for. The more you spend, the better the equipment. The advantage in photography, however, is that technology is at such a high level that even the cheapest cameras are excellently made. The following section gives some idea of what you can expect.

## Under $75

This includes the most inexpensive cameras, such as the Instamatic, most 110s, and some 35mm cameras. For this price you can also buy a selection of Kodak and Polaroid instant picture cameras. In most cases, the lens is made of plastic instead of glass, but it still yields surprisingly sharp pictures. These cameras sometimes come with a variety of special features, such as a device that prevents double exposures, a small bulb in the viewfinder that goes on when there is not enough light, flash attachments, or built-in flash. These cameras are obviously not intended for shooting magazine covers, but they provide the amateur with versatile and suitable equipment for taking top-quality photographs.

## $75 to $250

Here we find a wide range of possibilities. If you want a simple and convenient camera, one of the more advanced 110 models is perfect. They often have automatic exposure control, fast shutter speeds, and useful accessories such as zoom lens and motor wind. If you are interested in extra-sharp photographs, you can find a good 35mm camera in this price range. These often have shutter speeds up to $\frac{1}{500}$ of a second, built-in light meter, automatic focusing. In self-processing cameras, the Polaroid SX-70 is in this group.

Kodak Tele-Ektralite 600
This is the world's first pocket camera with built-in electronic flash that automatically turns on and off as needed. It also features a built-in dual-lens capability for telephoto effects.

All four of these new Kodak Ektra cameras accept 110-size film cartridges and have intregal cover/handles for both camera protection and ease of picture-taking. Two models are also equipped with built-in telephoto lenses.

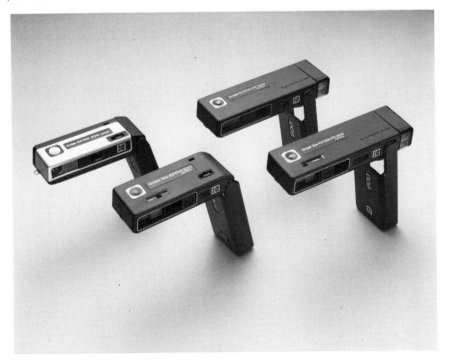

# $250 to $500

If you are prepared to spend this much, you are in an entirely different league. In this category we find the 35mm single-lens reflex (SLR), which allows you to see through the lens instead of through a rangefinder, thus insuring that your focus and framing is perfect. This section also contains the advanced 110 cameras. Both types, the 35mm SLR and the advanced 110, come with interchangeable lenses, very fast shutter speeds, filter systems, automatic controls, and a host of other features, all of which are dealt with under the appropriate headings in this book.

No matter what your reason for buying a camera or how much you spend, there are two essential aspects you need to consider: the viewing system and the lens.

# THE VIEWING SYSTEM

This is the way the photographer sees the picture when he holds the camera up to his eye and peers through the viewfinder. Cameras are usually classified according to four categories, depending on what kind of system is used. The first two types represent the older and larger cameras. Neither of these systems appears in pocket cameras, but knowing about them puts the newer technology into perspective.

The most basic type is the *View Camera*. Here the light comes directly from the object being photographed, through the lens, and onto a large viewing screen at the back of the camera. The image the photographer sees on that screen is *exactly* what will be captured by the lens. The screen can even be examined with a magnifying glass to check focus. These cameras are usually used for formal portraits, architectural scenes, still lifes, and scientific work. They are large and bulky, often with an accordion body.

The second is the *Twin-lens Reflex*. This has separate viewing and picture-taking systems. The classic example is the German Rollei. Light enters two lenses, each of which is connected to a set of mirrors which send one image to the film and the other to the photographer's eye.

There is a problem with this kind of camera, called *parallax,* which refers to the discrepancy between the two images. In the best cameras there is a correction for parallax built in.

The third type of camera is the *Single-lens Reflex,* or SLR. This allows the photographer to see through the lens, as with view cameras, but without having to use so much space in the camera. It is all done, as they say, with mirrors.

The SLR has a mirror arrangement that makes it larger and heavier than what would comfortably fit into anyone's pocket. Also, these cameras are more expensive than the viewfinder cameras (discussed next). Since they are more complex, they break down more easily. Finally, the camera is noisy because each time a picture is taken one of the mirrors swings loose and clunks against its base.

There are decided advantages to a single-lens reflex, however. It eliminates parallax: What you see is what the lens sees. The focus of various objects in the background and foreground is exactly as it will appear in the photograph. If there is anything in front of the lens, such as a lens cap, a camera strap, a long hair, or a finger, this will be immediately visible to the person taking the picture.

Parallax is the difference between what you see in a viewfinder and what the camera sees through its lens. Most pocket cameras use viewfinders, so you have to be careful to compensate for parallax, especially when shooting close up.

The fourth type of camera is the *Viewfinder,* or *Rangefinder.* Here the photographer looks through a small viewing window, set above or to one side of the lens, and sees an image approximating what the picture will be.

The viewfinder camera is undoubtedly the cheapest and easiest camera to use: smaller, quieter, and simpler than any other. You can just pick this camera up and shoot with a minimum of fuss or bother. Also, the best viewfinders are easy to read in dim light and more versatile in situations where an SLR would be limited or intrusive.

But there are drawbacks. The first is, again, parallax, where there is a discrepancy between the image the photographer sees and the image that appears in the lens. The more expensive viewfinder cameras correct for this automatically. Others have two sets of lines drawn on the viewfinder glass to indicate how far the parallax shift goes.

Other drawbacks include the fact that you can't take close-ups, and that the image one sees in the viewfinder, especially on the cheaper models, is very small, making focusing difficult.

# THE LENS

A lens is composed of one or more elements of glass or plastic which collects the light and sends it through the diaphragm and shutter to the film.

The first kind of lens is the *fixed-focus lens.* With these lenses the focus begins somewhere around six feet away. Anything farther away will be in focus and anything closer will be blurred. Of course, there is a great deal of compromise with a fixed lens. Much detail is lost in return for the ease of operation this lens offers. The fixed lens has *no* flexibility at all.

But its very simplicity is its greatest advantage. Since you cannot focus, all you have to do is point the camera and shoot; you have no responsibility for the sharpness of the image. Most of the 126s have this kind of lens.

A somewhat more sophisticated lens is the *zone focus.* This usually has three settings: 3 to 6 feet; 6 to 12 feet; and 12 feet to infinity. This gives the photographer some play in estimating the distance to the subject. It allows for more control but requires a bit more work. Most 110s have a zone-focus lens.

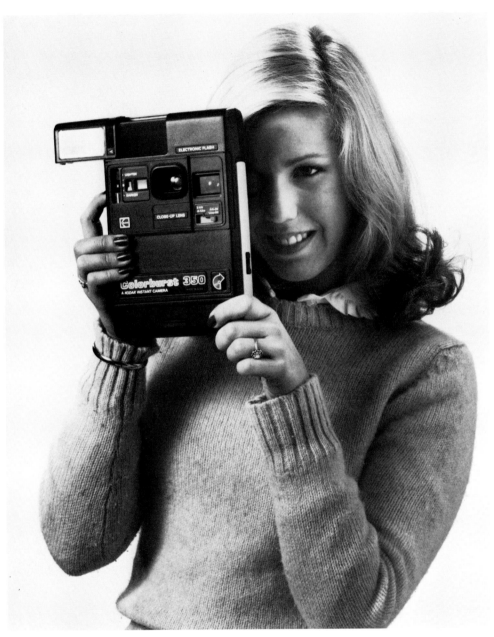

The Kodak Colorburst 350 instant camera uses Kodak instant color film to produce sharp, colorful pictures at distances ranging from two feet to infinity.

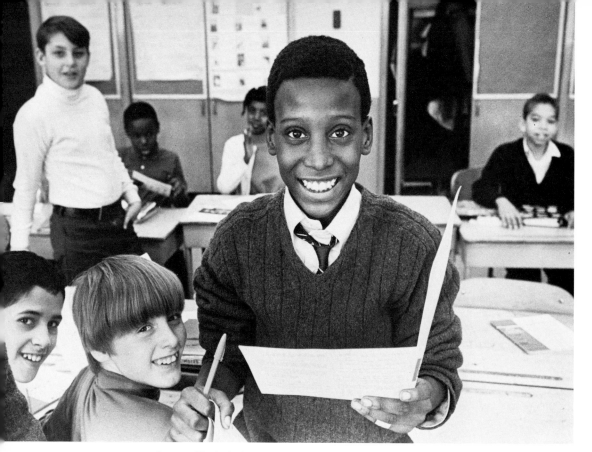

A young friend of mine took his Instamatic camera to school and passed it around, with each child taking a shot of classmates. While the result is not "professional," the photograph is warm and intimate.

Next is the *full-focus lens*. This is operated manually by turning the lens barrel. With this camera one can get the most accurate focusing possible. Full focus offers the most flexibility and opportunity for creativity, but this kind of lens is also the heaviest, as well as the most expensive.

And, finally, there is the latest development in this area, the *automatic-focus lens*. Here an automatic mechanism focuses the lens to the distance of the particular object that is included in a tinted spot in the viewfinder. By means of light images or sonar systems, the lens focus is adjusted without the photographer having to do anything but be aware of the subject on which he is focusing.

This system is fast, convenient, and—in the better cameras—extremely accurate. It might seem a dream come true, but there are disadvantages. The first is that it is not very good in dim light (although there are recent innovations using infrared devices which will improve performance; however, it will be some time until this problem is completely solved).

A second drawback is that if you focus on one object but another object is in front of it, that closer object will decide the focus depth and you will not have as strong a picture of what you were shooting as you had hoped.

Third, you have to be careful when shooting through glass. If you shoot at a sharp angle to the glass, you will not receive a true distance measure.

And, finally, these lenses are more expensive.

# THE CAMERAS

Once you have an idea of what kind of viewing system and lens seems to meet your needs best, it is time to look at the actual kinds of pocket cameras available. These may be divided into five basic types: 110, 126, 35mm, Self-processing, and the Mavericks.

## The 110

This is the classic pocket camera. Typical models are flat, small, lightweight, and easy to load (using a cartridge system). The more inexpensive models have a fixed-focus lens and a viewfinder, while the more expensive ones come equipped with single-lens reflex viewing, interchangeable lenses, and automatic focus. The medium-priced models usually have zone focus.

The major advantages of these cameras are, of course, portability, ease of operation, and economy. But there are, as with everything in life, negative features. The film size is relatively small, which means that the photographs can't be enlarged too much without losing sharpness. (One exception is the use of Kodachrome color film, which can be enlarged greatly with almost no significant loss of quality. There is also a tendency for camera shake to occur. (To minimize this hazard, many models have an electronic "sensor" in the shutter-release button which makes it sensitive to heat. You don't have to press the button; merely touch it.)

In most 110 models the exposure is set by moving a lever over a series of weather symbols: sunny, hazy, cloudy, and flash. The more expensive models come complete with full focus, including five or six f-stops.

Overall, the 110 lacks the precision and range of its more aristocratic counterpart, the 35mm, but it is simple, honest, and hardworking.

# The 126

The 126 (the most popular model is the Kodak "Instamatic") looks more like a 35mm than a 110, having a "snout" in which the lens, diaphragm, and shutter are housed. Like the 110, it uses a cartridge system for loading film. The 126 negative is larger than that used in 110s, so it produces sharper prints of higher quality.

Most 126 models have only a fixed-focus lens, and many have only one exposure setting. More expensive models have a range of weather symbols, but that is about as sophisticated as this camera gets. This type of camera uses flashcubes almost exclusively, with only a few models accepting flash bars.

By and large, the 126 is the least flexible and least expensive of the pocket cameras. It's hard to get a really bad picture with a 126. As many professionals have demonstrated, the 126 image is quite acceptable.

# The 35mm

This is the royalty of pocket cameras. As was mentioned, there are two basic styles: the single-lens reflex and the viewfinder. The 35mm SLR is the standard camera in the world today, and anyone seriously interested in photography should investigate its possibilities.

The 35mm viewfinder is somewhat heavier than the 110 and 126 but is still relatively lightweight. It has a very wide range of film available and many accessories. In film there are three standard grades of color print, seven grades of color slide, and four grades of black-and-white. Accessories include a "hot shoe," which is an attachment that holds a flash gun and eliminates the need for a separate cord for electricity to travel; various lenses (telephoto, closeup, wide-angle); filters; cable release unit; etc.

A recent innovation in this area is the "clamshell" camera. This refers to a camera body with a set of doors that covers the lens and viewfinder when not in use. The obvious advantage of this is that when closed it can be knocked around a bit without damaging the lens.

# The Self-processing Camera

The best known of this kind is Polaroid, of course, although Kodak is beginning to provide competition. This is the kind of camera that provides instant gratification: You see the picture within seconds. There are very few people who are not fascinated by watching a photograph develop before their eyes.

The breakthrough in chemical engineering which allows almost instantaneous development of photographs is one of the most radical innovations in the history of photography. And this advantage of immediacy has made the self-processing camera a worldwide success.

Due to the extraordinary popularity of this type of camera, I have devoted an entire chapter to the self-processing camera.

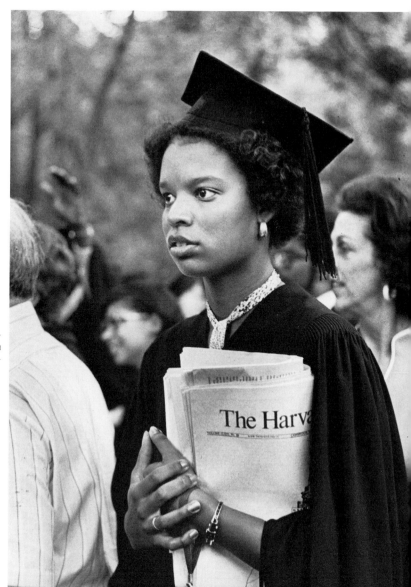

What is a graduation without a camera? To record this and other milestones in your life, a pocket camera is an invaluable tool. Here selective focus blurs out a messy background.

# The Maverick

There is a fifth type of pocket camera that is not widely used, and that is the detective or spy camera. This is the gadget that allows the photographer to take pictures secretly, to capture someone or something on film without anyone knowing that he is doing it.

The first detective cameras appeared in the 1880s, disguised as books, watches, luggage, etc. But the most famous of all was the "Kodak" introduced by George Eastman in the 1890s. The original Kodak was a box $3\frac{1}{2}''$ $\times 3\frac{1}{2}'' \times 6\frac{1}{2}''$, small enough to be used surreptitiously. These cameras underwent something of a fad, but the pictures they produced were of rather poor quality, so the craze died down.

There was another spurt in popularity in the 1930s, when the first quality miniature camera, the Minox, appeared. This kind of camera has appeared, both in fiction and in real life, in many a drama of international intrigue. The "miniest" Minox yet has just been made available. The Minox EC weighs only 2 ounces and measures $3'' \times 1'' \times \frac{1}{2}''$. It has a fixed-focus lens and automatic exposure, 15-exposure Minicolor film cassette, and a flash.

Another of these mavericks is the Wristamatic Model 30, an all-plastic camera that uses disks of color-print film and is strapped to the wrist. It makes six 10mm exposures on each film disk.

And, finally, we have the ultimate spy camera, the Tessina, which uses 35mm film in special thin cassettes. It has a number of options, including nylon gears which make it virtually silent to operate. The camera body is $2\frac{1}{2}'' \times 2'' \times 1''$, tiny enough to slip into a pack of cigarettes with room to spare! This, by the way, was the camera used by G. Gordon Liddy when he entered the Watergate apartments.

The problem with most of these subminiature cameras is that they use very small film. The negatives are so tiny that they can barely be enlarged to snapshot size without losing considerable quality.

When you have decided upon what kind of pocket camera you want to get (considering price, viewing system, lens, overall size, accessories, ease of operation, and general engineering quality), there are a few things to keep in mind about your new equipment.

# ▣ GENERAL CARE OF THE CAMERA

• Never leave a camera in direct sunlight, in a very hot or very cold spot. Extremes in temperature can warp the delicate casings and distort the mechanisms. The body should be kept free of all grease, dirt, and dust.

• Never drop or bang the camera. When carrying it, use a camera strap. It is easier than you think to have a camera knocked from your hand accidentally. Keeping it hung securely around your neck prevents accidents (and theft).

• Do not touch the lens, viewfinder, and rangefinder window. If touched, wipe the surface lightly with special lens-cleaning tissue or with a clean, soft cotton cloth. Fingerprints, if not removed immediately, will eventually become permanent.

• Store the camera in a dry, ventilated place. Many cameras come in a box with a bag of silica gel crystals to absorb moisture. Save the box and bag for storage.

• Remove batteries when the camera is not in use. This will prolong their life.

# ◙ KEEPING THE CAMERA STEADY

This is important with any camera, and especially so with pocket cameras, many of which have a fixed lens with a speed of $\frac{1}{60}$ of a second. The slightest camera movement will cause a fuzziness or even a blur.

There are a number of ways to aid in keeping the camera steady when you shoot.

The first, of course, is a *tripod.* For those cameras with an attachment for tripods, this is the best way to keep the camera from shaking. However, even the smallest tripods are awkward to carry around and can only be used in certain situations (not for spontaneous shooting).

A second trick is to use the *cable release,* a cord about a foot long which screws into the shutter trigger mechanism on one end and has a plunger on the other. Depressing the plunger affords much less risk of moving the camera than pressing the release button right on the camera body.

A third idea is setting the *self-timer* if your camera has one. When you do this you don't have to push anything to release the shutter. It happens automatically in five or ten seconds, depending on how long the timer runs. This means that you have a period of time to brace yourself while waiting for the click. In bracing yourself, by the way, don't be afraid to look a little foolish. It's all right to lean against a tree or a wall to get steady. But try not to switch positions too often or you might run out of time and have a blurry or funny-looking photo.

Finally, you can push the camera very tightly against your cheekbone or, if you have a vertical camera, against your forehead. And you can also wrap the camera strap tightly around your wrist so that the camera is jammed against your hand.

A relatively sharp object against a blurred background conveys the impression of speed; it is often much more effective than a sharp shot would be. This effect, called "panning," is produced by following the moving subject with your camera at a shutter speed of 1/30 of a second or less.

If you are shooting a moving subject, try the following:

*Panning*—This means following the subject with the camera as the subject moves. If your timing has been right, when you shoot you will get the subject in focus and the background as a blur. This provides a very interesting effect, giving much more of a sensation of motion than a frozen view does.

*Angle*—Try to get in front of or behind moving objects instead of at their side. A front or rear shot will be less blurred than a lateral one of the same subject at the same speed.

*Timing*—There is always a moment when something in motion can be captured perfectly on film. For example, if you are shooting someone diving into a pool, get the diver at the very peak of his dive when he is suspended for a split second. The same is true of a child on a swing.

Up to this point we've considered the history of the pocket camera and looked at the various types available today, with special attention to viewing and picture-taking systems. Now let's take a quick peek at those marvels of modern technology, the self-processing cameras.

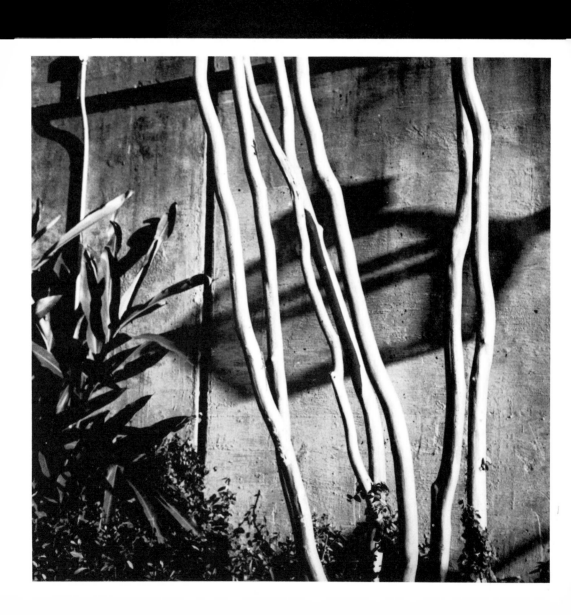

# Self-Processing Cameras (Polaroid and Kodak)

Edwin Land's introduction of the instant-picture camera is one of the two or three most radical inventions in photography. As I mentioned in the Introduction, the first photograph (in the 1820s) required several hours of exposure time. Currently, a roll of film can be developed and dried within one hour. But instant-picture cameras give you an image in sixty seconds—without a darkroom!

The advantages are obvious. Not only do you get instant gratification, but you have absolute privacy. You don't have to send your film to a lab. This, of course, made Polaroid synonymous with "bedroom photography," an image that the company has spent a great deal of money in overcoming. Now "Polaroid art" has become quite prestigious, with artists like Frank Gillette commanding as much as ten thousand dollars for a montage of Polaroid photographs. And very few people will forget that dramatic moment when Sir Laurence Olivier stepped onto the television screens of America in commercials for the SX-70.

There are, of course, disadvantages. One is cost. A Polaroid color print costs almost seven times more than a 35mm color print. At current prices, if you buy a ten-pack of film and a flash bar, each photograph will cost almost a dollar! Another problem is the lack of negatives in all but the most sophisticated positive/negative processes. It is possible to make duplicates of Polaroid or Kodak shots, but the process is more laborious and costly than using a negative to make one or a large number of prints.

These unassuming elements — a wall, some bushes, and the shadow of a street-lamp — make a very strong composition. This shot was taken with a Polaroid. Instant cameras can produce art if the photographer keeps his or her eye open for intriguing combinations of everyday elements.

However, judging from the popularity of these cameras, most people feel that the advantages outweigh the disadvantages. They certainly constitute a very large percentage of the photography market, and as instant-picture cameras become more sophisticated technologically, they will take over even more. Already it is possible to use Polaroid film with view cameras and certain 120 cameras such as the Hasselblad.

In approaching the self-processing cameras, a number of factors should be considered. In this chapter we'll take a closer look at these fascinating innovations in the development of photography.

# CHOOSING  A  CAMERA

If you are going to be taking mostly snapshots, one of the less expensive simple cameras will do fine. But if you want to take more precise photographs, you will need an SLR such as the SX-70. Here is a list which indicates some of the models available.

Polaroid 1000 One-Step. This uses a viewfinder, takes good outdoor pictures and portraits, but cannot be used indoors except with a flash or with a lot of sunlight coming through the windows.

Polaroid 2000 Pronto. Also a viewfinder camera, but it is capable of taking good pictures at night and acceptable action shots.

Polaroid 5000. This is an automatic-focus camera with a wider range than the 2000 series, capable of taking indoor pictures even in medium light.

Polaroid SX-70. This uses manual focus and can do everything well except take action shots because of its slow shutter speed. But it is a single-lens reflex, so focus and framing are exact. This camera can also take close-ups to within six inches.

Kodak EK160 and Colorburst Series. These are viewfinder cameras which can take outdoor and indoor pictures and portraits. They are good for action shots, but only in bright sunlight.

Kodak EK8. A rangefinder camera that includes a greater focus range for portraits.

Kodak EK2 and Handle 2. Viewfinder cameras with a relatively limited range of flexibility. These are best for outdoor pictures and portraits; they can take indoor pictures only when bright sunlight is coming through the windows.

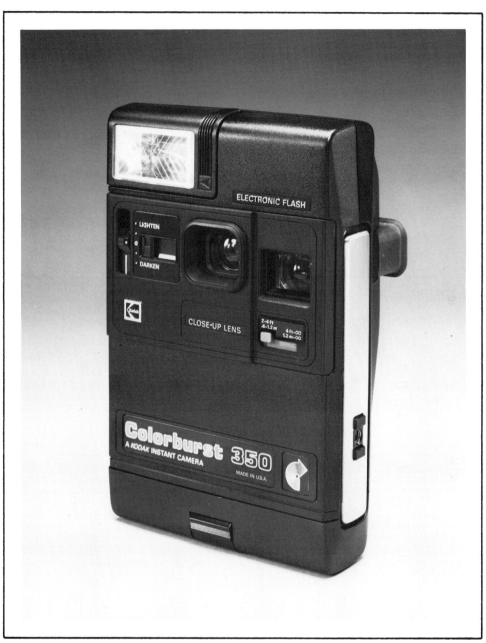

The Kodak Colorburst 350 instant camera features a slim look accented by bright metal side panels. The camera has a built-in exposure counter, a bright viewfinder, and a tripod socket. A colorful neck strap with metal fasteners is supplied with the camera. Recesses on the back of the camera accommodate pressure-sensitive initials supplied with each camera. The Colorburst 350 instant camera has a full three-year warranty.

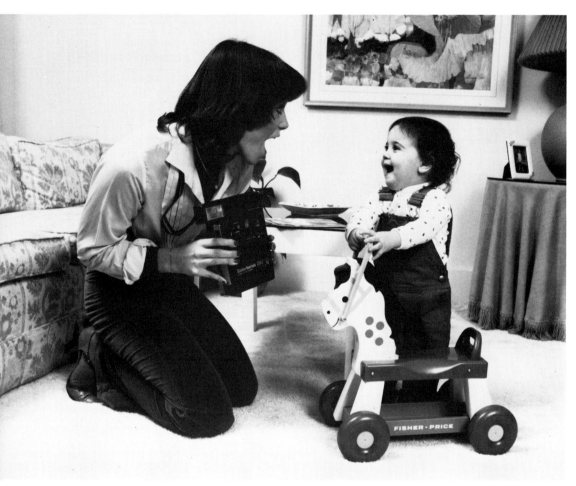

When the subject of your picture is a one-year-old toddler, you can move in close enough to fill the frame if you switch to the closeup lens on your new Kodak Colorburst 350 instant camera. This lens allows you to shoot in the two-to-four-foot range.

# FILM

There are two basic types of self-processing film: peel-apart and integral.

• Peel-apart film. This allows you to take instant pictures fairly inexpensively, both in black-and-white and color. After each shot you pull the film out from between rollers in the camera to begin development. After waiting for the amount of time recommended on the film package (usually sixty seconds), you peel off the backing.

Cameras that use peel-apart film require batteries to power the shutter, flash, and electric eye. They are viewfinder models, meaning that you look through a window above the lens. Accurate framing takes practice.

Only Polaroid makes peel-apart film, and a typical model using this film is the Polaroid Instant 30. This has an ASA setting of 75 for color and 3000 for black-and-white. (ASA simply refers to film "speed" or sensitivity; a slow film has an ASA of 25 to 100, a fast film such as Tri-X has an ASA of 400.) Exposure is controlled by an electric eye and a lighten/darken (L/D) control. The electric eye measures the light level and sets the correct exposure automatically, but because it can be fooled in certain situations (when there is strong backlighting, for example) you can set the L/D control manually. The camera takes regular or Hi-Power flashcubes.

• Integral film. This allows for true instant photography; the picture develops without your aid. Both Kodak and Polaroid produce this kind of film, but their systems are different, so you can't use Kodak film in a Polaroid camera and vice versa.

Most cameras using integral film automatically eject the print right after you shoot the picture; others have a crank handle to eject the print. Many of the cameras using integral film are also viewfinder cameras; that is to say, you look through a window near the lens. But some are single-lens reflex cameras, which means that when you look through the lens you get exact focus and framing.

These models also have an electric eye and an L/D control. Kodak cameras use a pop-up flash and Polaroids use a flash bar. A few models have an electronic flash built in.

#  DEVELOPMENT FLAWS

When the film is ejected and starts to develop, you may notice any one of a number of things wrong with your picture. These either have to do with problems in the camera or film or are due to temperature extremes.

• Specks or bars across the image. These are caused by dust and development fluid on the rollers in peel-apart film. Always keep the rollers in the camera clean.

• Part of the picture is blank. This is caused by squeezing the film pack before you load it into the camera. Always handle film by its edges.

• Fogged film. This is caused by light reaching the film before it is exposed. Never open the film door in the light.

• Bluish tone. If instant film is left out in the cold, low temperatures will cause the film to develop a bluish or pale washed-out tone. In temperatures below 55° for Polaroid or 61° for Kodak, you must place developing integral film inside your clothing so that body heat keeps the picture warm. Below 65° peel-apart film should be stored in a "cold clip" (your dealer will sell you one) and then placed inside your clothing.

I often use a Polaroid to test the lighting when photographing models. Here I used a white background and stronger light for the woman and a gray background and more moody light for the man. Don't forget that each change of light produces a new quality in your picture — especially portraits.

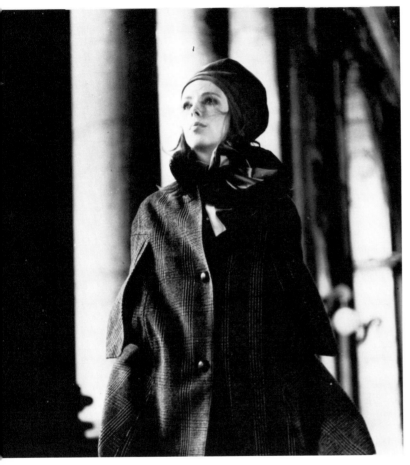

This aspiring model asked me to do some test shots for her portfolio. I used a Polaroid and took her to Manhattan's Municipal Building to use columns as a backdrop, making her look much taller than she actually is. I also turned the light/dark control toward dark to make the contrast greater. Thus, using even the simplest cameras subtle effects are possible.

# BLACK -AND -WHITE VERSUS COLOR

Most people consider color to be superior in all circumstances, but this is not the case. Black-and-white film is definitely superior in some instances.

Black-and-white film, for example, is available with an ASA of 3000. This is *very* fast, which means that you can shoot in low-light conditions, such as dawn or dusk, night shots, and indoors.

While color is more flashy, black-and-white can give you "moody" effects that are just as powerful. Also, black-and-white is cheaper than color, and you can get positive/negative film with a negative you can use for making more prints. The pos/neg film has an ASA of 125.

With black-and-white film you can take double exposures. For example, shoot a view of a mountain range with the L/D control on light. This will give you a faint image. Then move the L/D back to normal and take a picture of a friend lying down. When the film is developed, you will have a shot of your friend seeming to sleep on a bed of mountains.

Another trick is to use pos/neg film and have the negative printed on harsh-contrast printing paper at a professional lab. This will give you a "pen-and-ink" effect.

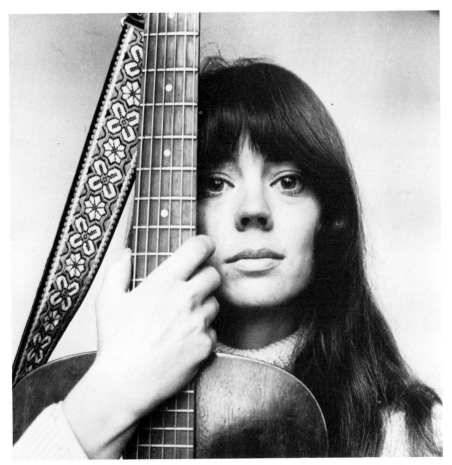

This instant-camera shot became a study in form (note the triangle formed by the guitar strap and the outline of the model's hair) as well as a lovely picture of a sensitive artist.

# ◉ SPECIAL TRICKS

There are a number of games you can play with self-processing film. I cover some of them in the section on Abstract photography in Chapter 8, but here are a few more.

• Put a screen in the pack. If you cut out a shape in a thin screen and slip it into the film pack, your photos will come out framed within that shape. You have to make sure the screen is very thin and slide it gently under the film cover.

• Write a message on a screen. Write or draw something on a clear plastic screen and insert it into the film back. Your photo will come out with the words or design superimposed upon it.

• Slip a flat object in the pack. Put any flat object, such as a leaf or an abstract design, between two plastic sheets and slip these into the pack. Then whatever you shoot will have this shape superimposed above it.

• Photograms. Place a small, flat object on a piece of integral film which you have removed from the pack in dim light. Then place the film and object on a flat surface that is brightly lit. You will get a fascinating pattern with unpredictable colors.

With any camera having f-stops, to get a blurred background (or selective focus) you can open the aperture as wide as possible. But with the SX-70 the lens opening is fixed. To get the same effect I posed the model twenty-five feet in front of some trees, so that she stands out sharply and the background becomes totally indistinct. Also note the soft light and relaxed expression on the young lady's face.

Fill-in flash in action. The top photo was taken in bright overhead sun; the man's hat completely shades his face. The bottom photo corrects this problem by adding flash to illuminate these shadows.

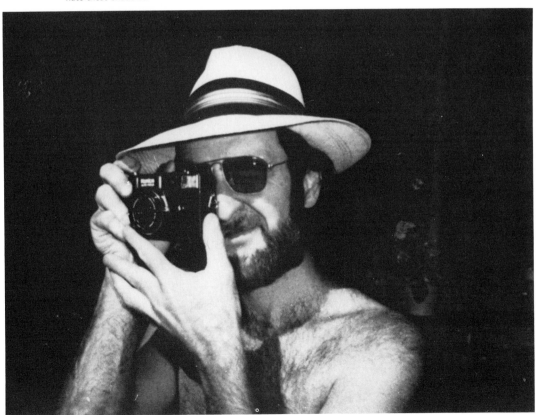

This high-school girl was very nervous, but instead of asking her to relax I asked her to stand even more stiffly. The exaggeration made the picture amusing. Later we took a series of more casual photographs.

## 📷 MOUNTING AND STORING PRINTS

This whole subject is covered in Chapter 10, but with self-processing film several guidelines are necessary.

• Don't write on prints. A pen may break the dyes on integral film and pencil or pen marks will show through peel-apart film.

• Don't use glue, rubber cement, or cellophane tape on your prints since they may cause a chemical reaction that will spoil the colors.

• Don't cut integral film. You will release caustic fluid which can burn your fingers and destroy the print.

• Don't dry-mount an instant print; the pressure can distort the image.

• Never display pictures in direct sunlight, even under glass, or they will fade.

# ACCESSORIES

The more expensive cameras come with various accessories, including tripod, interchangeable lenses, filters, etc. But the most important are the telephoto and closeup lenses. Telephoto lenses allow you to shoot details from a distance and fill in the frame. They are also good for natural-looking portraits and candids.

The closeup lens allows you to do intricate detail work with patterns, flowers, and still lifes. A closeup lens on the SX-70, for example, allows you to get within five inches of the subject.

Even though the self-processing cameras have already captured the imagination of tens of millions of people, they are still in their infancy. In the near future you will be able to find instant cameras matching the best 35mm cameras in precision engineering.

My recommendation is that even if you have a 35mm or 110, you should also have a Polaroid or Kodak for those moments when only instant development will do.

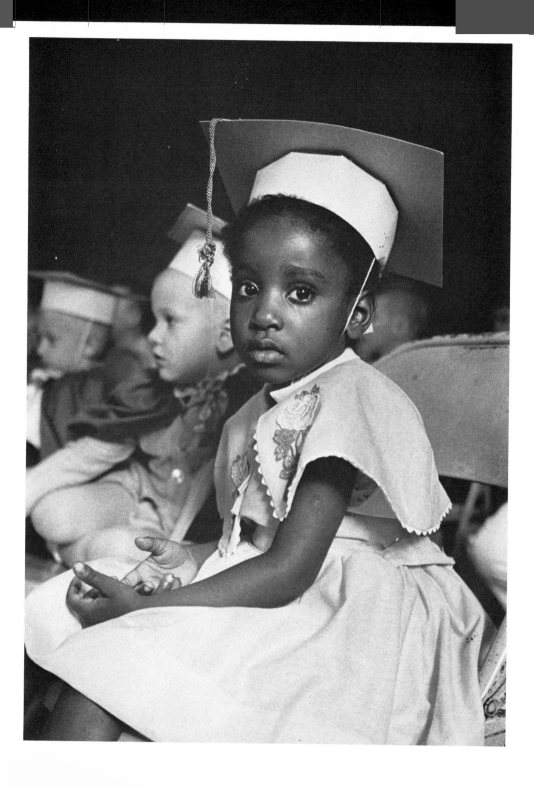

# A Choice of Film for the Pocket Camera

With today's cameras there is a wide range of films available, all of which are the result of a very high level of technical sophistication. In choosing among the various films, there are several things to consider: film size, method of loading, black-and-white or color, speed (or sensitivity), and price.

## 🔾 FILM SIZE

Film size refers to the width of the film strip. Generally speaking, the larger the size of the negative, the finer the quality of the print.

## 🔾 LOADING THE FILM

There are basically three methods: cartridge (used in the 110 and 126), spool (used in the 35mm), and flat case (used in the instant cameras).

---

I caught the slightly bewildered expression of this beautiful child in natural light using the Olympus XA, with automatic exposure, and Tri-X film.

# 📷 BLACK-AND-WHITE OR COLOR

Black-and-white is cheaper and has a wider tolerance for error in estimation of light. Many professionals and artists consider it more "aesthetic." Color is more expensive and trickier to use, but it captures the object totally, in full color. Black-and-white film produces negatives which are then converted into regular prints; color film comes in two types: print and slide. The instant cameras have several types of film in both black-and-white and color.

 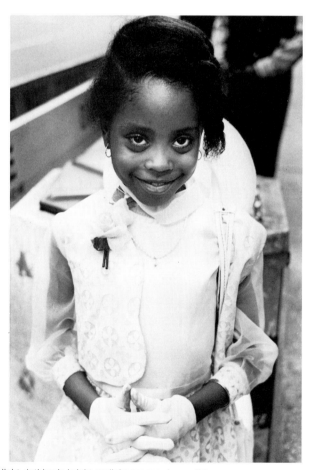

The contrast of dark skin and light clothing in bright sunlight poses an impossible exposure problem. If you expose for the white dress, the skin will go too black; and if you expose for the dark skin, the dress will burn out. In the first picture (A) taken with an automatic camera, the result is an overall gray. In the second picture (B) the problem is solved by professional developing and printing. For extra special photographs, such as this First Communion shot, it is worth spending two dollars to have a custom lab supply selective controls in printing the negative, giving the blacks and whites their proper balance.

The combination of fast motion and poor light at this amusement park ride required the use of a fast speed (1/125 sec.), which in turn required that the film, Tri-X, be "pushed" to an ASA of 1200. There is some loss of quality in the grain and tones, but the excitement of the moment is captured.

# 📷 SPEED

This is sometimes called "sensitivity." Different films are more or less sensitive to light; the more sensitive they are, the "faster." This senstivity, or *speed,* is denoted by an ASA number (for the American Standards Association). Faster film requires a smaller lens opening and/or a quicker shutter speed; slower film requires a larger aperture and/or slower speed.

High-speed film allows you to capture high-speed events. It also allows you to work in dimmer light. However, when these films are enlarged they are more fuzzy than enlargements of slow-speed film. ASA numbers usually range from 25 to 400 (although speeds of up to 1600 are readily available). 25–32 ASA is considered slow film; 64–125 medium, and 160–400 fast. A doubling of the number indicates a doubling of the sensitivity of the film. This, of course, affects exposure.

# ◙ PRICE

Color film costs significantly more than black-and-white. And 35mm color film is more expensive than 126 or 110. Polaroid or Kodak instant is the most expensive of all. If the cost for a black-and-white print is given at ten cents, then color would cost forty cents, and a Polaroid print nearly a dollar.

# ◙ WHICH FILM FOR WHICH CAMERA

## The 110 Camera

These use film cartridges which have a larger spool at one end. Loading the 110 is absolutely foolproof. It is impossible to put the film in the wrong way and still close the camera. Also, when the roll is finished, you simply remove the cartridge; it is not necessary to rewind.

The negative is small (11mm $\times$ 17mm), which means that only a limited enlargement is possible before the picture begins to lose sharpness. The major exception is Kodachrome film, which is so sharp that even small 110 negatives can be enlarged almost as well as 35mm film, and it is likely that film technology will improve to the point where 110 film will be able to do just about everything you can do with 35mm.

110 color film is available in both slides and prints. Slides are returned in small mounts, but you can get larger mounts which adapt 110 slides to 35mm projectors.

110 film is the least expensive, but as of now it comes in a limited range of films. For black-and-white there is only one speed: ASA 125; for color prints there are only three speeds: ASA 80, 100, and 400; and for color slides only ASA 64.

## The 126 Camera

These cameras also use cartridge film and they share the foolproof features of 110 film. The negative is larger (28mm $\times$ 28mm), which allows for sharper enlargements. 126 slides come in mounts that fit a standard 35mm projector.

126 film is also inexpensive, but your choices are limited. For black-and-white there is only one speed, ASA 125; for color slides ASA 64, 100, and 160; and for color prints ASA 80 and 100.

You can make a statement using the difference in scale between people and their background. Here the massive windows of this Wall Street company make the man seem puny in comparison. The extra sharpness comes from Kodak's Pantatonic-X film.

The combination of lighting and low camera angle makes this friendly pet seem almost majestic.

# The 35mm Camera

Film for this camera has three advantages over both the previous types of film. It is cheaper per shot; the negatives are larger (24mm $\times$ 36mm); and there is a far wider range of film types and speeds on the market.

However, 35mm film is slightly more difficult to load. A spool is inserted in one end of the camera body. A small piece of the film is left sticking out of the spool, and this must be hooked to a sprocket system at the other end of the camera. Occasionally, if the film is not well enough secured, it will slip off the sprocket and no film will be run past the lens opening. Also, after the roll is finished, the film must be rewound. And, finally, larger film requires bigger and heavier cameras.

Color prints come in ASA 80, 100, and 400; color slides in ASA 25, 50, 64, 100, 160, 200, and 400; and black-and-white in ASA 32, 125, 400, and 1250.

For information about film for instant cameras see Chapter 2.

# 📷 FUN FILM

There are several other kinds of film that are not generally known but can be bought in any good photo store and are fun to use.

The first is *high contrast* film (also known as "line" and "Kodalith" film). This film has no gray tones. Everything comes out either black or white. This creates stark photographic effects which can turn a humdrum scene into a startling image. It is also possible to take existing ordinary negatives and turn them into high-contrast prints. Any good professional photo lab can do this for you.

A second fun film is *infrared,* a heat-sensitive film used for industrial and medical purposes. This film has its three layers of emulsion sensitized to green, red, and infrared instead of blue, green, and red. The result is a modified or "fast color" rendition of a subject. Greens come out flaming red, browns as blue, turquoise as violet, etc. This is a chancy film; you're never sure exactly how the picture will turn out. But infrared is fun to play with. It has to be kept in a refrigerator until used and must be loaded and unloaded in total darkness.

The Kodalith process is used to drop out the grays of a photograph. Here a similar effect is achieved in this charming winter scene by the use of high-contrast paper (Agfa #6). Any professional lab can do this with any black-and-white photograph.

# CARE AND HANDLING OF FILM

It is clear that there are a number of different kinds of film for different cameras and different purposes. This brief introduction can only give you an overview of what's available and some technical terminology so you can buy and discuss film knowledgeably.

The best practice is to buy one kind of film and use it exclusively until you completely understand it. After a while you will know almost instinctively what aperture and speed to use for all kinds of light conditions for each kind of film.

Here are some tips on the care and handling of film that will prevent errors that could cost you some irreplaceable photographs.

1. Always buy fresh film. Check it by looking at the expiration date stamped on each box. This stamp is required by law. Don't buy any film that is less than a month away from the expiration date.

2. Store film in a cool, dark place. The refrigerator is good, but be careful of moisture condensation. Also, do not place film on or near anything hot.

3. In a damp climate (or when film is stored in the refrigerator, as mentioned above) keep film in a sealed plastic bag with moisture-absorbing silica gel capsules.

4. Do not load or unload film in direct sunlight. Theoretically, the cartridges, cannisters, and cases in which film comes are lightproof. But a strong sun can burst into the tiniest opening and ruin much of a roll.

5. X-ray machines in airports can fog film. Some machines give off a much higher radiation than others. Also, on a long trip your camera bag may pass through such machines a number of times; repeated exposure may affect the quality of your film. You can either ask for a hand check, in order to sidestep the scan device, or keep your film in a lead-lined bag (available from any large camera store).

6. After you've finished a roll, process it as soon as possible.

7. Each roll of film comes with a set of instructions. Kodak film, for example, includes a data sheet in each package. This contains specific information for that film only, including suggested aperture openings, speeds, shutters; the use of various flash devices; and processing tips. Study it carefully.

*four*

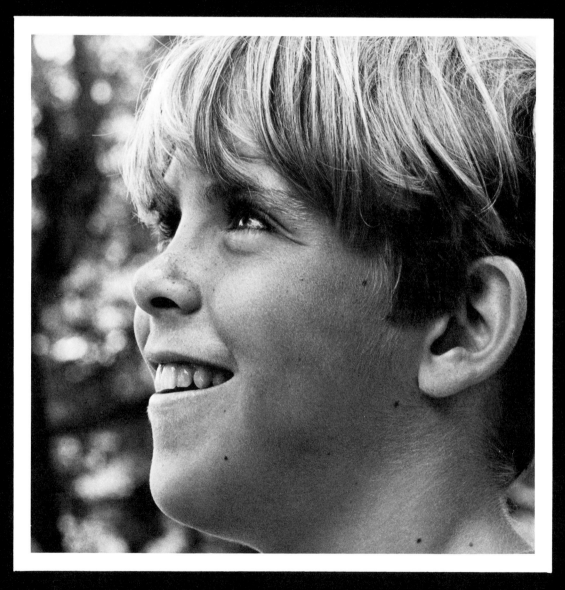

# Exposure in Natural Light

Light is the essence of photography. The image that is captured on paper is simply the pattern of reflected light.

Many professional photographers feel that understanding light is the single most difficult aspect of photography. And, indeed, there have been hundreds of books written in dozens of languages discussing this very subject.

Light creates the hues in color photography and the tones in black-and-white. All variations in light—intensity, texture, source, and direction—affect the mood and message of a picture.

Light is the photographer's medium just as paint is for a painter. A photographer must first learn how to *see* and *use* light in order to become sensitive to its changes. And then he or she must learn to see light the way a camera and film will record it.

Poets have written about light and physicists have tried to measure it. Artists often travel thousands of miles to such places as Greece or the south of France, where the light has a special quality.

Obviously, a complete discussion of light is outside the range not only of this book but of any book. However, from this vast subject we must select those aspects which relate directly to the taking of photographs.

---

Portraits taken in a studio provide perfect light but often make the subject seem stiff and overly posed. Outdoor portraiture involves the risk of tricky lighting, but you will get more natural and pleasing expressions. This photograph was taken with cloudy/bright light.

# ◨ WHAT IS EXPOSURE?

Exposing film to light is the essential action of photography. Exposing film correctly means controlling how much light falls on the film and for how long. In addition, we must consider the kind of film being used.

Exposure is the means by which light is controlled. In modern photography exposure control depends on three factors: shutter speed, aperture size, and sensitivity of film used.

Good exposure technique (coupled with good developing technique) insures that your photographs will be as sharp as possible, with rich tones and textures. So it is important to understand how these exposure functions work. Even if you own a pocket camera with a fixed or automatic lens, knowing the fundamentals of exposure will make you much more alert to the factors that determine the quality of your photographs.

The first element in exposure is *shutter speed*. Primitive cameras using metal plates as film often required an exposure time of several hours. By the turn of the century this had been reduced to several minutes for most subjects. (Portrait studios had head clamps on their chairs to help hold the heads of the subjects steady during long poses.) Cameras used in science now have effective speeds measured in the millionths of a second. And contemporary popular cameras have speeds ranging from 10 seconds to $\frac{1}{1000}$ of a second. In fact, from the earliest light-sensitive materials to modern ultrasensitive films, speeds have increased more than 23 million times.

The faster the speed, of course, the more briefly light falls on the film. So in very bright light you can use a higher speed to reduce the amount of light that strikes the film.

The advantage of using a fast shutter speed is that you can "freeze" moving objects. Also, if you should move the camera there is less chance of blurring the image.

Simple cameras, such as the 126 and the cheapest 110s, have one speed, usually $\frac{1}{60}$ of a second. But the more expensive 110s, 35mm, and some instant cameras have speeds ranging from 10 seconds to $\frac{1}{1000}$ of a second.

The second aspect of exposure is *aperture,* or the size of the opening through which light is let into the camera. Aperture is scaled according to the degree to which the diaphragm opens.

High-priced 110s and all 35mm cameras use a system of f-stops which commonly go from f/2.8 (wide open) to f/16 (the smallest opening). On the simplest cameras, there is only one opening, usually set at f/11 or f/16, and good only in bright light. Medium priced 110s use weather symbols. "Bright sun" indicates a small lens opening; "hazy sun" a slightly larger opening; "heavy overcast" the largest opening. Instant cameras generally have a "darken" to "lighten" knob which allows the photographer to control the amount of light.

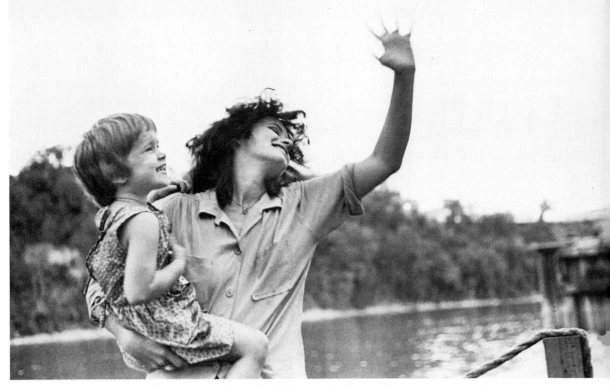

A slow shutter speed against backlighting blurred the fingers of this woman dancing with her child, accentuating the feeling of movement. I used a low camera angle to increase the mood of exuberance.

With aperture one thing should be kept in mind, namely, *depth of field.* Depth of field is defined as the zone of sharpness in front of and behind the subject. So if the available light is dim and you want to increase exposure, using a wider aperture may blur the background or foreground. In that case use a slower speed and keep the aperture small.

Both aperture and speed are measured in units that are interchangeable. A one-stop change in either speed or aperture halves or doubles the exposure. For example, if you go from $\frac{1}{60}$ to $\frac{1}{30}$ of a second, you let in twice as much light. If you go from f/2.8 to f/4, you let in half as much light. Thus, f/4 at $\frac{1}{500}$ of a second gives exactly the same exposure as f/11 at $\frac{1}{60}$ of a second. The difference is f/4 will give a narrower depth of field than f/11.

The third aspect of exposure is *sensitivity* of the film. I covered this in the last chapter, but here it would be good to remember that there are fast-, medium-, and slow-speed films. If you have some idea of what kind of light you will be using when you shoot your next roll of film, you can choose your film sensitivity (measured in ASA units) to match the shutter speed and aperture settings available on your camera.

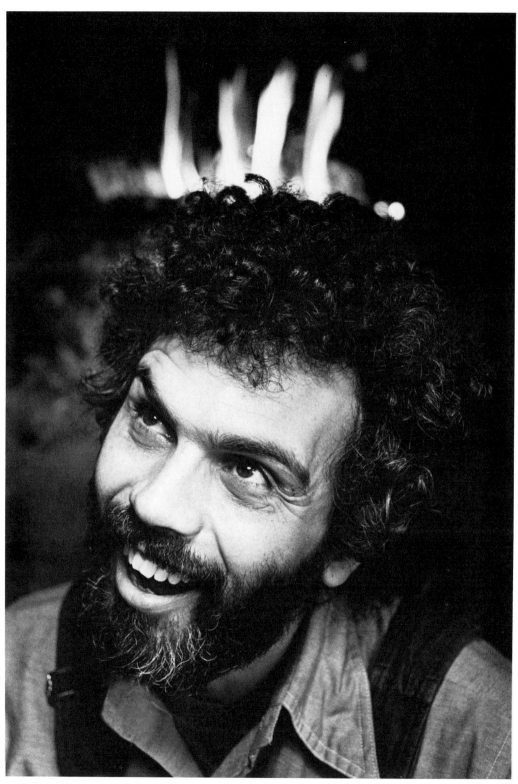

I wanted to use natural light in this portrait of the renowned writer Marco Vassi, so I used a tripod to avoid camera shake at 1/15 of a second. The slow speed also caused the flames behind his head to blur, producing an eerie effect.

# ▣ HOW TO GAUGE PROPER EXPOSURE

With a simple "point and shoot" camera (such as the 126), both the speed and aperture are fixed. These cameras usually have an f/16 lens with a $\frac{1}{60}$ of a second shutter speed. This means that with medium-speed film you can only shoot sunlit objects. But with ASA 400 you can shoot in shade, cloud, backlighting, or even in poor light indoors.

With totally automatic cameras, of course, there is no problem. Using highly sensitive photo sensors, these cameras "read" the available light and automatically adjust lens and shutter.

The best of these automatics, however, have a manual override which allows the photographer to do his or her own adjustment. Many photographers want this feature because it allows them to be more creative.

With all cameras that have manual control of exposure (the medium- and higher-priced 110s, 35mms, some of the instant cameras, and automatics with override), it is necessary to fix shutter speed and aperture size yourself. And the two tools to help you to do this are the light meter and the chart.

*Light meters* are either built into the camera or come as a separate unit. In both cases the principle is the same. The meter is keyed for the ASA number of whatever film you are using and then it "reads" the light and gives you the appropriate exposure data—f-stop and speed.

Built-in meters use a moving pointer or warning light that can be seen right in the viewfinder. Self-contained light meters are usually about the size of the palm of your hand and use a moving pointer to indicate f-stops and shutter speeds.

*Data sheets* are charts provided by the manufacturer with each roll of film and/or package of flashbulbs. They are extremely useful in making determinations for exposure. They are quite dependable; if you do exactly what they say you should, you will rarely get a bad picture. They discuss various lighting conditions and suggest different combinations of aperture and speed. I spoke about them in the previous chapter and will here repeat my advice to study them carefully.

If at any time you are uncertain about whether you are using the right exposure, a good thing to do is to "bracket" your photograph. Say you are shooting something at f/4 at $\frac{1}{60}$ of a second. You would then also shoot it at f/2.8 and f/5.6 at the same speed. Keep a list of which pictures you took with which method. In this way you cover the possibility that your reading or estimation of the light might be off target. Also, you might get results with the "incorrect" settings that are more satisfying than what you get with the "correct" setting.

# 📷 UNDERSTANDING NATURAL LIGHT

In considering light, there are five factors to take into account: quantity (or intensity), quality, color, source, and direction.

## Quantity or Intensity

The first question a photographer must ask when he or she is about to take a picture is, "How much light is available?" From a single candle in a dark room to the blazing sun at noon, there is an appropriate film, speed, and aperture.

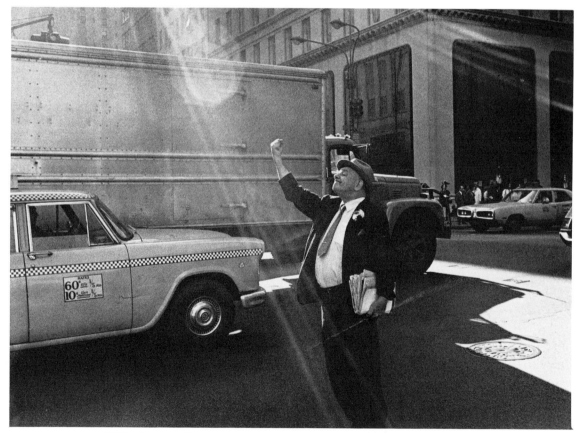

This is what professional photographers call a "grab shot," meaning that there is no time to think, much less set controls. I took this with an automatic camera and was assured perfect aperture and speed to capture this pungent street scene.

Portraits don't have to be taken head on. While in Japan I asked this Zen master to pose for me. He surprised me by turning away from the camera and it wasn't until I received the developed picture that I realized he had "revealed more by showing less."

# Quality

This is a more subtle factor than quantity. Here, instead of asking, "How much light is there?" the photographer asks, "How *good* is the light?" For example, if you want to take someone's portrait, doing it in bright sunlight is not a good idea because the light is too harsh and makes the skin look washed out. The light on a "cloudy/bright" day is gentler and more flattering.

When you consider the quality of light, think of the following concepts:

*Hard light* refers to using a direct flash, harsh overhead lights, or the mid-day sun. It is good when you want to pinpoint detail, but it destroys all atmosphere.

*Soft light* refers to the light on a cloudy day, the moody light of dawn or dusk, or when you use lamplight. When using flash, you can soften the light by bouncing the flash off the ceiling (see Chapter 5).

The quality of light governs the texture and tone of the photograph, and part of training your eye is learning the distinctions between the various subtleties of light.

I caught this intimate portrait on the Staten Island Ferry using the Minolta 110 Zoom SLR in soft, natural light. This telephoto lens is unobtrusive and allowed me to shoot this couple from across the aisle without disturbing them.

# Color

This is another subject that could fill volumes, but for the purposes of this book, there are only a few important things to remember.

One is to look for *strong* colors. This is color that is vibrant and bold and attracts the eye immediately. It requires bright, or "hard," light to bring out its full brilliance.

*Muted* color is the opposite. It is romantic or bleak. Sometimes it can be extremely dramatic. It often comes about in haze, rain, or smoke. This, of course, requires "soft" light.

Color *contrast* refers to colors that are opposite one another on the color wheel: blue and yellow, red and green, etc. It is not necessary to know the technicalities, but you should become sensitive to sharp color contrasts in nature and in man-made environments. These make your photographs stand out vividly.

*Isolated* color refers to picking out an object with vibrant color that is standing against a background that is neutral or monochromatic, such as a red boat on a blue sea, a black dog on white sand, etc.

It is also necessary to consider the color not only of the object but of the light itself. For example, in the morning or evening sun the light has an almost orange or reddish hue. Afternoon light is bluish, especially the shadows.

Different films are tipped toward one end of the spectrum. Kodachrome, for example, emphasizes reds, while Ektachrome favors blues. If you would like a certain tone in your photos, talk to your dealer and ask for suggestions on which film to buy.

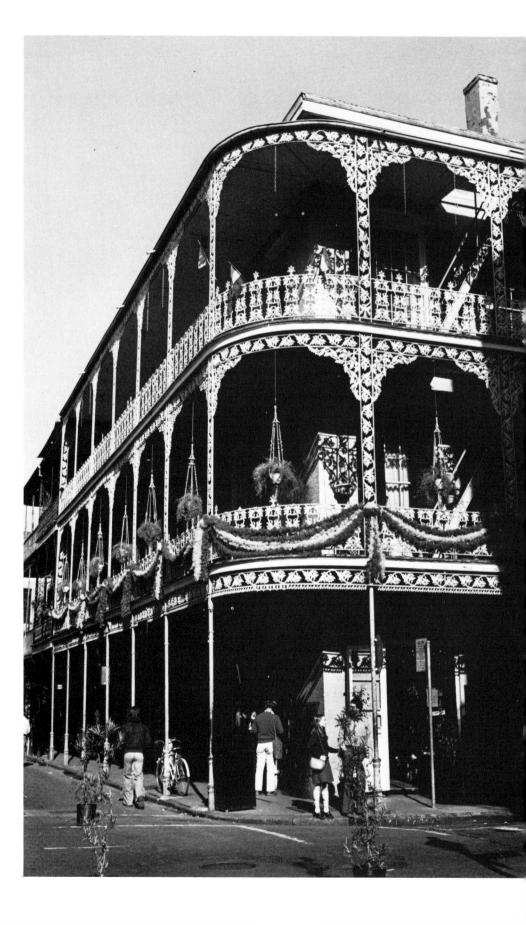

# Source

For available natural light there is only one source, and that is the sun, which appears under a variety of conditions: the molten red-orange of dawn, the white-hot sphere at noon, the mellow yellow of afternoon, and the return to red and orange at sunset. There is even one rarely seen optical effect in which the sun glows emerald green for several seconds!

However, we shoot not only in the sunlight but in the reflection of sunlight. In fact, most of our light is reflected. Thus, as you size up various photographs, consider how much light is being bounced into your field of vision by buildings or other objects. If you are shooting someone in shadow, you might even hold a white cardboard sheet to use as a reflector of the available sunlight.

The biggest reflector, of course, is the moon, and shooting by moonlight is a special study. It requires fast film, wide aperture, slow shutter speeds, and a real grasp of exposure technique in general.

---

Shooting in the French Quarter of New Orleans, I found the morning light unsatisfactory to capture the spirit of this building, so I returned when the late-afternoon sun turned the wrought-iron trellis silver. Each time of day has a different angle and intensity of light, so don't be afraid to take the same picture several times to capture a variety of moods.

# Direction

Light can come from above, below, behind, in front of, the side, or from all around (diffuse light).

Light from *above* is least favorable. I once shot a model in Central Park. It was about noon, and the bright overhead sun was causing her to squint and making her skin look parched. So I moved her into an underpass where she stood in deep shadow, but with a lot of light reflected from a nearby pond. This softer light brought out her features and allowed her to relax her face.

Light from *below* is melodramatic. It will make a subject seem sinister or menacing. However, this is more a question of artificial light, which will be covered in the next chapter.

*Sidelight* is used to give contour to a subject. However, it is risky because it can create odd shadows on a person's face. Mid-morning or late afternoon are the best times to use side lighting. Photographs taken at those hours are often very striking.

*Front light* is standard. This relates to the most basic rule in all photography: "Stand with your back to the sun." While light from other directions can be used for various effects, front lighting gives the best possibility for a successful photograph.

*Backlighting* is the most tricky. If your subjects are standing between you and the sun, there are two things to do. First, "read for the subject." This means going up to the subject with your camera (if it has a light meter built in) or with your light meter and getting a reading close to the subject's body. Then set the lens for that reading and step back to take the picture. The subject will be properly lighted and the background will be extra bright. Quite often a halo effect is created. The second thing to do is to shade the camera by holding your hand above the lens so that it is shaded from the sun.

*Diffuse lighting* is perhaps the best. This occurs on cloudy/bright days. This light is soft, even, and very flattering for portraits.

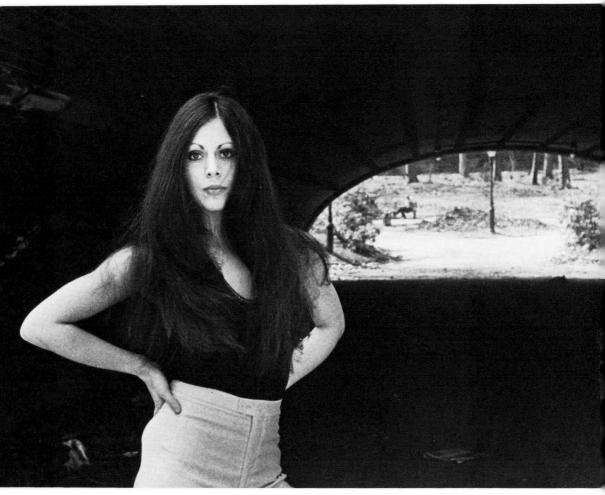

I was shooting this model in Central Park, but the bright overhead sun was making her squint and washing out all her skin tones. So I had her stand just inside an overpass. The reflected light brought out all the sensual qualities of her skin, as well as allowing for a relaxed pose. Also, the dark inside of the tunnel against the light at the end frames the photograph perfectly.

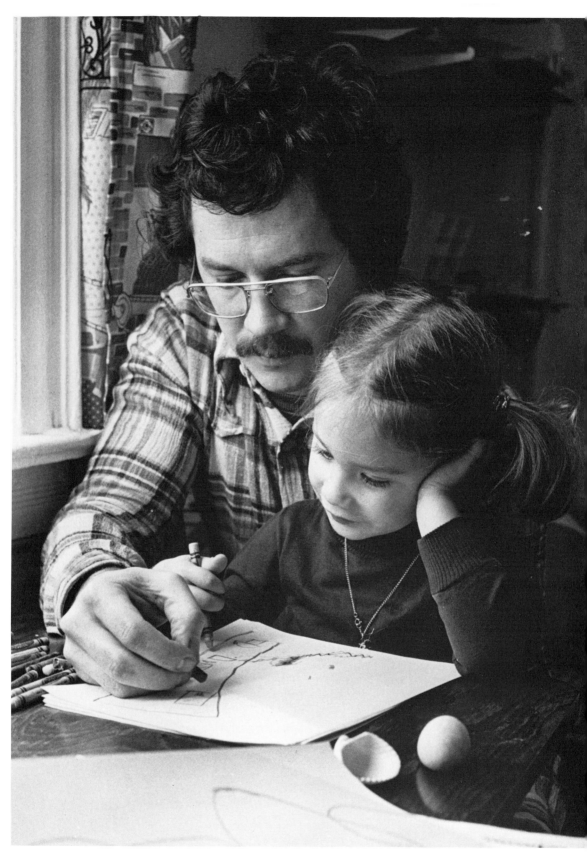

Move in close for better pictures of parents and children. Try to catch the special warmth of the parent/child relationship as you compose the scene. Here I use soft window light instead of flash for a more naturalistic photograph.

# TIPS FOR USING NATURAL LIGHT

1. If you are working in dim light or want to use very fast speeds ($\frac{1}{1000}$ of a second), you can "push" your film. This means setting the ASA indicator on the camera for a higher speed than the actual speed of the film. For example, if you were using ASA 400, you might set the indicator at 800 or 1600. This gives you more film speed. However, when film is pushed, it develops with more grain and a harsher, less pleasing tone.

2. You can gauge exposure without a meter by establishing a standard guideline. In bright sun set your lens at f/16 and then set shutter speed at the ASA number of the film you're using. For example, with ASA 64 film you would set the shutter at $\frac{1}{60}$ of a second. From that point you can play with speed and aperture for changes in light during the day.

3. It is worthwhile to get up early some days for dawn photography. There is a quality of light at sunrise which is unique and will provide you with eye-catching photographs.

4. Always check your batteries before taking a trip. Batteries are used for the flash and to activate various parts of the camera, such as auto-wind, exposure meter, etc. Carry extra batteries in your camera bag and use only heavy-duty batteries.

5. When shooting at night, use a flash. Also, be sure to use as fast a film as possible—at least ASA 400. You may have difficulty with an exposure meter because night light is so tricky, so when you do get a reading bracket it by taking several shots with different readings, some with long exposures.

6. Be aware of what professional photographers call "separation." This refers to the distinction in tone or color between the subject and the background. For example, if you shoot someone against a background of similar color or tone, you will lose the clear edge of the subject's body. For strong, clear pictures make sure that there is a well-defined separation. You have a few choices for good separation: Move the subject so that the backdrop is of a different tone or color; move the camera so that it gets the subject against a different background; change the light; change depth of field to "shallow" so that the background blurs out; or change the background itself.

7. Every once in a while use a roll of film just for experimentation, not for subject matter. Take your camera and play with it. Don't be concerned about the outcome. You'll be surprised what you might come up with. Relate to your camera not as an alien machine but as an extension of your mind.

# Artificial Light, Flash and Filters

In the last chapter we talked about natural light, the light of the sun. Now we are going to discuss artificial light, the light created by man. For the purposes of photography, artificial light can be broken down into two types, ordinary and enhanced.

*Ordinary* artificial light comes from the regular tungsten light bulbs and the fluorescent bulbs found in most homes and businesses.

*Enhanced* artificial light is created in one of three ways: using lighting, flash, or filters.

Let's explore enhanced artificial lighting a bit.

## 📷 LIGHTING

Lighting is a subject that frightens many amateur photographers because it seems so complex. Most people have an image of a Madison Avenue studio with sophisticated lighting systems and teams of experts crawling over the set carrying light meters, wires, cables, and all manner of strange photographic devices.

---

Since it is against house rules to take pictures during a performance, the best way to take theatrical pictures is to go to dress rehearsals that use full stage light. Such light is very dramatic, so choose poses that make the most of it.

It is true that there is no end to the possible subtleties one can find in the area of lighting. But it is also true that a person needs no more than two or three photoflood bulbs, stands, and reflectors in order to accomplish a very wide range of effects.

With the lights themselves, however, a few other accessories are extremely useful: a tripod, for those cameras with the necessary attachment, to insure sharpness of focus; a cable release for releasing the shutter without having to depress the shutter button or in any way touch the camera; a separate exposure meter for reading the light changes in various parts of the scene to be shot.

The basic kinds of lighting are front, side, back, bounce, and edge. (There is also top and bottom lighting, which were discussed in the previous chapter.)

*Front,* or direct, light is a light pointed right at a subject. Contrary to popular opinion, direct light is the most difficult for amateurs to use. It is much brighter than any of the other types, but it is usually very harsh and unflattering in portraits. It flattens surfaces, eliminates most of the mood, and deprives objects of their visual individuality.

*Bounce* light refers to pointing the light at a wall, ceiling, or other reflecting surface. This gives a soft, diffuse light and is the best all-around approach to use indoors.

*Edge* light involves turning the reflector so that the light beam is aimed in front of or behind the subject, with only the edge of the light beam falling on the subject. In this way the subject is both in and out of the light at the same time, which gives the photo a slightly mysterious quality.

*Back*lighting as used in the studio creates a silhouette effect and sometimes turns the subject's hair into a glowing halo. This lighting is usually dramatic. The technique is often used by fashion photographers, but it is tricky, and the photographer has to remember to "read for the subject" (see Chapter 4), but it is well worth experimenting with.

*Side* lighting with flash or artificial light is quite useful in creating captivating effects because the photographer can control the degree to which some things are highlighted and others obscured.

Of course, all of these kinds of light can be used in combination. The possibilities are limitless.

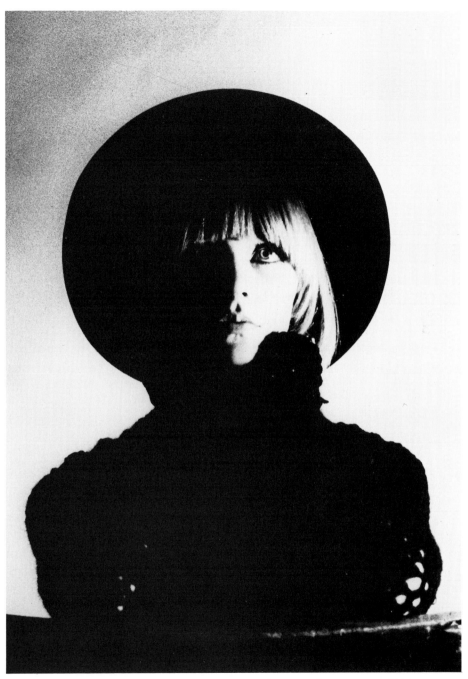

A strong sidelight, a black hat, and a sweater combine to transform a teenage girl into a high-fashion model.

# Shadows

While experimenting with these various angles and approaches to using light, you should become sensitive to shadows. Shadows are generally divided into two kinds, sharp and soft. Without them most pictures would look dull or unreal. Shadows are a tool in helping us define space, but they can also be confusing.

You should look out for sharp-edged shadows. These can be disastrous when photographing someone's face, for example, and they can distort the sense of volume. Most photographers prefer soft shadows because they are more flattering, adding grace to the lighter portions of the photograph.

Also, when shooting color notice that some shadows take on the hue of the colors surrounding them. Some shadows may come out with a bluish or reddish tinge, while others may appear gray and lifeless.

When working with lights it is a good idea to move them around in a wide range of combinations until you have the kind of shadows you want. You can learn to use shadow creatively to add mystery and enhance composition, introducing a professional touch into your photographs.

# ◻ FLASH

Using a flash has several advantages over regular lighting. It is cheaper, much more portable, and doesn't involve standing in front of hot light bulbs that can raise the temperature of a room considerably.

The disadvantage, of course, is that you cannot take your time playing with various effects. The flash is instantaneous; you can't study the scene as it will look when the flash goes off.

There are various types of flash. The *built-in flash,* found in 110s and 35mm models, are powered by batteries that are inserted into the back of the camera. On most cameras it is necessary to throw a flash switch, at which point the flash pops out, and when it is ready to fire a "ready light" appears.

The advantage of a built-in flash is its portability; there's nothing extra to carry. The disadvantage is that it is placed very close to the lens and so creates a flat effect on the subject. Quite often it brings about "red eye" (see page 63).

Another type of flash is the *plug-in unit.* This includes the flash bar, flash-cube, and pop-up flash. The advantage with these is that the flash is a bit removed from where the lens is. But the plug-in units are more expensive than the built-in flash and must be carried around and disposed of.

The third type of flash is the *flash unit,* a spearate piece of equipment. On 35mm models and some 110s the flash unit fits into a "hot shoe" on the top or side of the camera. These units have a wider area face from which the light is projected, thus giving a softer, broader light. They also provide more precise lighting control than built-in or plug-in flash models.

The fourth type of flash is the *slave.* It also does not need to be attached to the camera. It has a sensor which is activated by the flash on the camera, and instantaneously triggers its own flash so quickly that its light also illuminates the photograph.

Slave flashes are used when there is "flash fall-off." This refers to what happens when you are shooting a group of people and only those in front are well lighted. The slave flash is placed in such a way that the back of the group or scene also receives enough light. In addition, one can use slave flashes to bounce light off ceilings and walls. Slave flashes can be attached to clamps and placed anywhere in the room.

There are very sophisticated flash units nowadays which can be "set." There is a dial where you register the ASA of the film you're using and the f-stop at which you are shooting. The flash will then read the distance to the subject automatically and give off exactly the right amount of light. Some of these units even save unused power for future flashes.

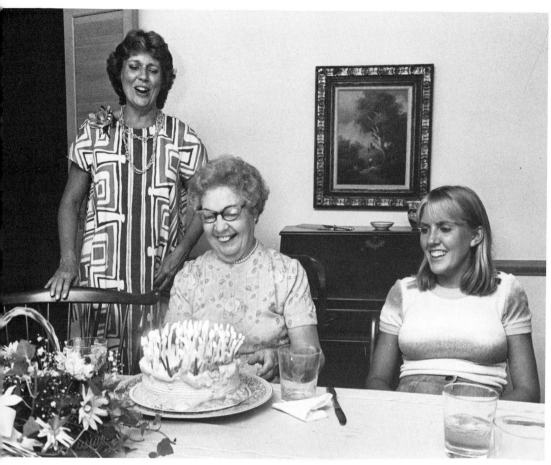

Here I used bounce flash off the ceiling for a soft, overall illumination. Otherwise the candles would have highlighted the grandmother's face and left the other two women in shadow.

The world's first pocket camera with built-in electronic flash that automatically turns on and off when needed.

# Things to Remember When Using Flash

1. All flash units have some power source. This is almost always batteries, although some can plug into the wall. For the amateur the main problem with flash is usually a weak or bad battery, or corroded battery contacts. Always have a fresh set of batteries in your camera bag.

2. With flash units it is often necessary to use a sync cord, which goes from the unit into the camera body. This is very delicate, so there is often a problem in the wire or one of the connections. It is a good idea to have an extra cord along with the spare batteries.

3. Distant subjects require more flash illumination than closer ones. Automatic cameras do this adjustment for you. With manual models open up the lens one f-stop for each five feet of distance.

4. Sometimes it is good to use a flash even when you might not think it is needed. For example, if someone is standing next to a window in sunlight, a flash will fill in the area away from the sun. This practice is called "fill-in flash" and is very useful in achieving even lighting over the entire photograph.

5. It is possible to "paint" with light. Put a camera on a tripod and put the shutter on "bulb," thus keeping it open. Now, using a flash unit, walk around the space in front of the camera and shoot the flash at random. You can illuminate the whole room or just parts of it. You can have a picture with yourself in ten different places in the room at once. This technique was used in photographing the insides of the pyramids in the 1840s, except that instead of flashes (which weren't invented yet) early explorers such as the British photographer Francis Frith used torches with shields on them.

6. Watch out for "red eye." This occurs when the flash reflects directly into the eyes of the subject. It occurs in close-ups of people or animals when an on-camera flash has been used at subject eye level. To avoid this either use off-camera flash or tell the subject to look slightly away from the camera. Interestingly, some fashion photographers have begun to use red eye as a technique, using a ring light flash (a circular flash that fits around the lens). They figure that this makes the photo more "catchy."

7. Use flash for bright color. Toward the end of day, or when the sky is overcast, there is not enough light to do justice to the colors of many subjects. A flash will simulate sunlight and brighten colors.

8. You can create softer lighting by covering the flash head with a white handkerchief or piece of gauze. This will cut down on the harshness of the flash and produce a more diffuse, flattering light.

9. When you are using more than one light source, turn the second one on and off many times, carefully observing the difference. When you use a second light to enhance the first, you may also destroy some of the qualities created by the first light. Doing this "on-off" trick will train your eyes to detect subtle changes.

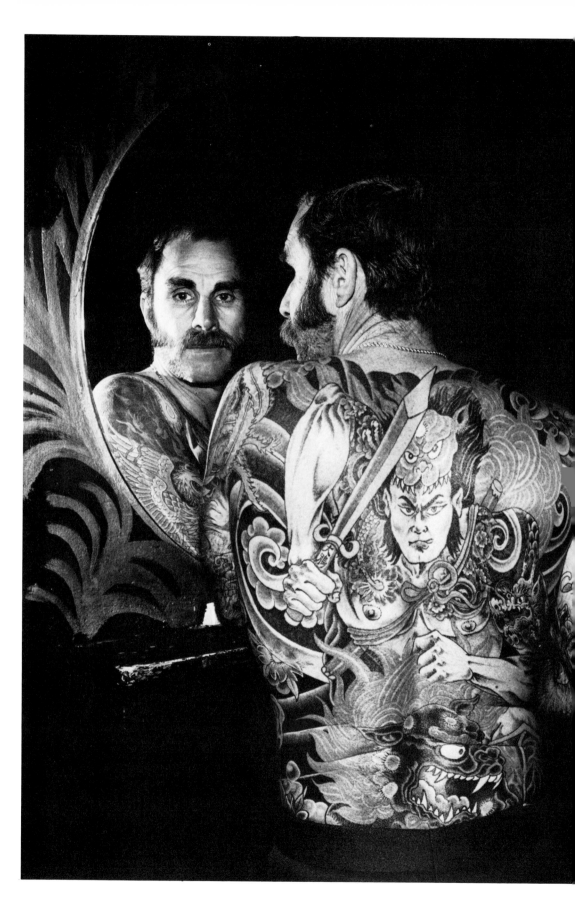

# FILTERS

The first two methods of changing light—lighting and flash—involve changing the environment by changing the intensity, source, and quality of light. The third method, filters, allows you to play with light without changing the scene. You simply slip one of these special plates over your lens and you can radically alter the pattern, color, and texture of light that falls on the film.

Filters are the secret weapon in the arsenal of the professional photographer. They can be used to heighten color, change mood, and even to alter the subject beyond recognition.

There are dozens of different filters, but the most commonly used ones are available for some 126 cameras, many 110s, all 35mm models, and many instant cameras. Learning how they work involves a bit of study and experimentation, but the results should more than repay the investment in time and energy.

This man had just won the "Most Beautiful Tattoo" award of the year. I posed him in front of an art nouveau mirror so I could capture not only the extraordinary designs on his back but the seriousness of his facial expression. The light was provided by bounce flash.

Your pet can be on television. When shooting a TV screen, you have to use 1/30 of a second or less in order to get a complete picture scan. This requires holding the camera very steady or using a tripod.

# The Way Filters Work

A color filter allows light of its own color to pass through and absorbs or blocks the light of other colors. How much light is absorbed and how much is let through depends on the intensity of the filter color as well as its place on the spectrum. In general, hues close to the filter color will pass through, while complementary colors are stopped. Thus, a yellow filter stops blue but lets most orange pass.

Filters for black-and-white film relate to the particular way that such film responds to color. Black-and-white film is more sensitive to some colors than others. It is less responsive to yellow and more sensitive to blue than the human eye. Also, black-and-white film is fairly sensitive to ultraviolet light, thus making the sky appear lighter in pictures than it does to our eyes. Filters of various colors compensate for this and also help you highlight certain parts of the photograph and attain richer texture and contrast.

There are various types of filters, the most common of which are the following:

*Ultraviolet and Skylight Filters.* The colorless ultraviolet or "haze" filter blocks out ultraviolet radiation which we can't see but which is recorded on film. This often shows up in the background of distant shots as bluish haze. The skylight filter is faintly amber-tinted and reduces the bluishness of light in deep shade or on generally overcast days. This is a subtle change, but it enhances color photographs significantly. Since neither of these filters adversely affects black-and-white film, professional photographers often leave them on the camera to protect expensive lenses.

*Polarizing Filters.* Light that is reflected from water or glass is polarized, that is, it vibrates in only one plane. The polarizing filter blocks light traveling in that plane, thus reducing glare from water or panes of glass. This filter has many other uses, including darkening a blue sky, screening out atmospheric haze, and giving richness to colors.

*Color-correcting Filters.* The chief filters in this category are yellow-tinted or blue-tinted. These are necessary when you are using tungsten film outdoors or daylight film indoors. Tungsten film produces a bluish hue in daylight; the filter that compensates for this is yellowish-orange in color. Daylight film produces a golden hue indoors; the filter that corrects for this is blue.

*Fluorescent Filters.* The most widely used kind of fluorescent light, cool white, usually gives photographs a greenish tint. This is corrected by two filters: FLD, or Fluorescent Daylight, for daylight film; and FLT, or Fluorescent Tungsten, for tungsten film. Other types of fluorescent light will take other kinds of filters.

I take my Minolta Weathermatic to the beach without fear of its being damaged by salt, sand, or surf. Once, when I was alone, instead of hiding my camera under my beach towel I simply buried it in the sand for safekeeping.

Shooting at the beach is tricky. Get to know how to cope with reflected glare off sand and bright water. An ultraviolet filter is also very useful.

On assignment to photograph these weapons, I had to shoot through a glass case. To avoid glare, I used a polarizing filter. This works best with a single-lens reflex camera since you can see the degree to which the filter is reducing the glare.

*Soft-focus Filters.* These are used to soften focus, to make a subject or scene appear gentler. The same effect can be had by breathing on the lens or putting a filter that has been smeared with Vaseline over the lens.

There are many other types of filters, but most of these produce special effects, which are covered in Chapter 9.

The final thing to know about filters is that, to one degree or another, they all cut down on the amount of light that falls on the film. Thus, they require a larger aperture and/or slower speed than you would use without the filter. The change is called the "filter factor." If a given filter has a factor of two, it means you must double the amount of light. Filter factor is also frequently given in f-stops.

You can buy standard-size filters for any 35mm camera and for the more expensive 110s. With the cheaper 110s, with 126 cameras, and the self-processing cameras you can buy gelatin filter squares and tape them to your camera front.

Instant-picture cameras like the Polaroid also take special filter holders manufactured by the company. With these you cut the gelatin to fit the holder and then slip it over the lens.

With this chapter we have completed our introductory tour of the pocket camera. We've covered the historical background of pocket cameras, different types of pocket cameras, film, and all aspects of exposure and light.

In the next chapter we are going to deal with that perennial question of how much of this equipment you should bring on a trip. What is the balance between comfort—carrying as little as possible—and safety—making sure that you have all the equipment you need for the best possible pictures under all possible circumstances?

This photograph shows an everyday scene, a subway entrance, bathed in mysterious light. Sharpen your perceptions until everyday subjects are seen in a compelling light, causing you to stop, appreciate, and capture their magic.

# The Traveler's Camera Bag

Travel is one of the most exhilarating and energizing activities possible. Every day is a new experience. And travel is one of the easiest ways for the average person to be rejuvenated. Doing the simplest things—ordering a meal, getting on a bus—involves constant challenge when dealing with a different language or different customs.

The effect of this is to heighten your perceptions—and when you have a new perspective on things, this is the perfect time to take photographs. We have all had the experience of waking up in a new place and looking out on the world as though it were a brand-new place, much as a child sees things. It is at moments like these that you want your camera to capture the freshness of your vision.

Travel and photography naturally go together. Everything on a trip goes by so quickly that the eye and brain are overworked. Photos help you to sort out your memories at leisure, re-experiencing your trip and sharing it with friends. And, indeed, except for rites of passage such as confirmations, bar mitzvahs, weddings, etc., people take more photographs when traveling than at any other time.

However, until recently photographers have had to pay for the pleasure of taking travel pictures with the burden of having to carry around a heavy camera. Until now the 35mm single-lens reflex has been the standard traveler's camera—and it is somewhat bulky. Having it hang around your neck or shoulder for ten hours a day can take a lot of the fun out of using it.

When shooting architecture in foreign countries, try to include people in the photographs to show the relationship of the population to the culture. With pocket cameras you can take photographs unobtrusively, whereas with a larger, more noisy camera you might offend local religious sensibilities.

But there has been a vast improvement recently. First of all, the 35mm SLRs themselves are being made smaller and lighter. But the most radical change has come with the introduction of pocket cameras. The appearance of these marvels of miniaturization has been the single greatest boon to travelers imaginable. Now it is possible to go around the world taking photographs of everything in brilliant color while carrying an instrument not much bigger than a pack of cigarettes.

However, when going on a trip some choices must still be made. The basic question is, "How much should I take?" Well, you don't have to take anything but a slim 110, with no accessories or lenses, and you'll get enjoyable shots of your trip with a minimum of fuss. But to give you an idea of how far you can go on the other end of the spectrum, consider the following list of items found in the camera bag of one professional photojournalist:

> one 35mm single-lens reflex (Canon)
> two 35mm rangefinders (Leicas)
> five different lenses
> one strobe light
> one light meter
> several lens caps and shades
> spare batteries and sync cords
> a set of filters
> some lens tissue and lens cleaner
> a clamp tripod (6 inches high and weighing 3 ounces)
> a packet of tools for first-aid camera repair.

The entire collection weighs a little more than 25 pounds! Imagine slinging that over your shoulder and walking through Rome on a hot day!

Whichever kind of camera you choose, the point is to make sure that you have sufficient equipment to get all the shots you really want, and to be able to compensate for special conditions of light and distance.

I would say that if you want to take anything more than the bare camera, you should at least have zoom-lens capability (many 110s have a built-in zoom), and the capacity to take filters.

There are also specialty cameras for different kinds of photography. The best known of this type is the underwater camera. Up until now you had to buy special housing for your regular camera in order to make it waterproof. But this was an expensive procedure, one that made an already bulky camera heavier and bigger.

The granddaddy of the underwater camera is the Nikonos, but it is rather expensive. Now, however, there are relatively cheap cameras available with some very nice features.

There are 110s that are leakproof and can even be buried in sand without damage. Some have built-in flash, easy-frame viewfinder, a five-position focusing dial, and a fixed shutter speed of $\frac{1}{200}$ of a second. They can take pictures down to a depth of fifteen feet underwater. And many of these remarkable cameras actually float.

Sometimes mood is more important than technique. In this photograph the sense of introspection and isolation is dominant. Don't get so involved with technical aspects that you forget real human feeling.

# ◼ TRAVEL TIPS

When traveling, your mood is usually one of excitement. The idea is to "get away from it all." However, this very mood may make you a bit careless when it comes to taking the photos that will serve as the record of the trip, the "frozen memory." So there are a number of things it is good to keep in mind. The following tips will help you to insure that your photographic journey is as joyful as it can be.

• The first bit of equipment you should get is a good camera bag with a sturdy strap. These come in a number of sizes, depending on how much equipment you are going to carry. But the bag should be big enough to hold all that you need and protect it from damage.

• When you leave the country, register all your camera equipment with the customs office. This can be done at any international airport. Otherwise, when you return you may have trouble proving that your equipment was not purchased abroad and you may be charged a tax for it. If you buy photographic equipment abroad, keep all receipts and be prepared to pay tax for it on the way home.

• Take twice as much film as you think you will need. It is better to be safe than sorry, especially since you will not be able to buy Tri-X, Kodachrome, or other familiar films in many foreign countries, and you may have to rely on an inferior quality of film, or a film with specifications you don't understand.

• In carrying your film, make sure you keep it away from X rays (as in airport terminals) and heat. Also, you may want to take along some silicon gel to put next to the film if you are going to be spending time in damp or rainy places.

• Respect the customs of the land you visit. In many countries the people have a religious taboo against "graven images" and will resent your taking their photograph. In communist countries, taking pictures of airports, train stations, seaports, etc., is forbidden and your film will be confiscated (even photographs you took elsewhere) if you break their laws in this area.

• Always take all film and camera equipment on board with you when taking a plane. Never check cameras or film with the rest of your baggage.

• As sad as it is to say this, in many places in the world the price of a good camera is the equivalent of a month's or even a year's wages. Don't tempt people by leaving your camera lying around, or even leaving it in a hotel room while you are out. Also, when carrying your camera put it around your neck or wrist with a strap.

No formal picture of the White House could be as revealing as this homely detail from the fence surrounding the building. One is surprised by the fact that the grille around the button box is bent, showing that even the highest places of power have their foundation in human nature.

• It's a good idea to keep a log of your trip. Include the date, place, and a brief description of events. Then key the pictures into the journal entries. When you show your photographs you will have an interesting commentary to go along with the visuals.

• Don't just document the public side of your trip. Also photograph the personal and intimate aspects. Take pictures in your hotel room when you are doing ordinary things. Capture the private moments so that the photographs won't seem to show nothing but a guided tour through a museum.

• If you never shoot black-and-white, take along some black-and-white. If you don't like color, take along some color film. There will be times during your travels when one film is more appropriate than the other. In the late evening, for example, when the light is weak, you may need to use a fast film, and you'll need black-and-white. Some shots would lose their magic in black-and-white, so color should be used, even by those purists who think that color is "less artistic" than black-and-white.

• Instant cameras can be a great deal of fun on a trip. I know a man who traveled around the world paying his way with Polaroid snapshots. In villages throughout Africa, for example, he'd take a picture of the chief and his wives and be rewarded with room and board for a few days while he was treated like a royal guest. Instant cameras are fantastic icebreakers. You can take a picture of a child on a street in Peking and give it to her mother and suddenly have made a new friend.

• Some places have specific customs in relation to photography. In Morocco, for example, there are groups of street children, snake charmers, fire eaters, etc., who will pose for you if you give them a few coins but will be insulted and even abusive if you don't pay them. The money is not much—a few pennies—but respecting the attitude of others is very important.

The charm of this photograph emerges the moment the viewer realizes this riot of colorful forms is actually a pile of house slippers in a discount bin.

This is the band at Syracuse University. If you look at the left of the photo you'll notice the top of a saxophone. I was shooting a football game when it began to rain, and the band covered up in these orange slickers. Using a telephoto lens, I was able to get a close shot even though I was sitting quite far away.

For successful nature close-ups you need a great deal of patience. Wait for an insect to settle, preferably on a flower of contrasting color. Use a diffuse flash to bring out color and detail.

There are many ways to photograph flowers. Here I pulled apart a lily and scattered the leaves over a piece of soft fabric. The result is obviously contrived yet engages the eye in a captivating fashion.

n this photograph I was experimenting with various shades of red. I recommend that you play with color in this way to sharpen your eye for different hues.

This picture was taken at a distance of five inches using a Polaroid SX-70 with a close-up attachment.

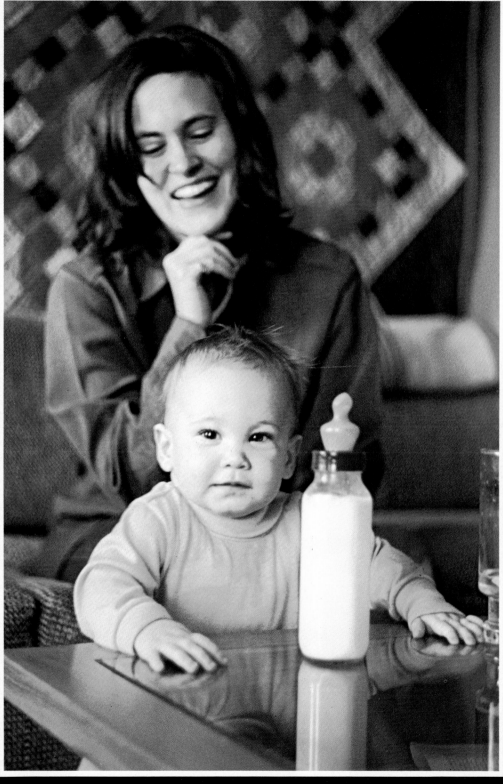

A simple family snapshot can be viewed on many levels. The elements in this photograph include soft window light and the obvious affection of the mother for her child.

Visual puns occur when incongruous elements are brought together in an offbeat or humorous manner. Here a detail of a man painting a billboard over the Boardwalk in Atlantic City looks like one of the famous soft sculptures of Claes Oldenburg.

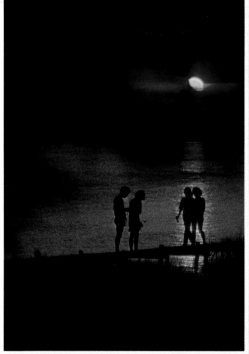

A wide-angle lens captures fascinating light patterns in this shot of the Temple of Karnak in Egypt, and gives some idea of its monumental scale.

To capture a beautiful sunset like this use a camera with adjustable speeds. Bracket this shot by changing the speed or f stops, and then select the best shot after the photos are developed.

I shot this photograph of singer Al Green using high-speed Ektachrome film and a bounce flash. I later asked a custom lab to enlarge just his face and chest. This is the dramatic result. Examine your photographs with an eye for extracting and enlarging details to create a stronger picture.

This photograph shows the importance of adding the human element to travel photography. I spotted the bright colors of these houses and waited until two people walked by, giving the shot a sense of motion and life.

This picture was taken during the Mardi Gras. I posed the youngsters out of the bright sun, against a wall, so that could capture them with an uncluttered background, free distraction.

hile photographing in a New Orleans nightclub, I used ounce flash to softly illuminate a foreground that otherwise ould have been pitch black. A proper mixture of bounce ash and daylight can be very effective.

This dreamy effect was achieved by an inexpensive 126 camera with a slow shutter speed. Sharpness is not always better, and you can put the "disadvantages" of a cheap camera to good use.

Strong, simple composition and intelligent use of color separation can turn the most commonplace subjects into striking photographs. Here a light underexposure increased the color saturation.

Filters can be used to enhance or change any mood. In this photograph of sailboats on the Nile, I used a yellow filter to bring out the radiant glow of sunset.

The real charm of this tiny house in Burano, Italy, is its striking color. Can you imagine the same photograph in black and white?

When I saw this tomato in my garden, I knew it was a picture.

Be alert to visual opportunities on the street. The cold winter air caused condensation on a restaurant window, giving this neon sign an eerie effect, perfect for photographing.

Putting some kind of design element in the foreground of a picture can enhance the effect. Here I placed a wrought-iron lamppost in front of sunlight bouncing off railroad tracks, turning a pretty picture into one with strong composition and framing.

The magic of this photograph lies in the play of dark and light in the features of the stone face, contrasting with the red graffiti made by some anonymous street artist. In this case, using fill-in flash would have destroyed the dramatic effect.

There are times when keeping the cage in a photo taken at the zoo adds visual appeal while making a statement. Kodachrome film gave the color extra pizzazz.

This picture shows the importance of "seeing like a camera." I was taken by the color of the goldfish in the water against the pink flamingos, forgetting that the goldfish would photograph so small that they would be barely visible. Always remember that the camera sees objectively while the photographer sees subjectively. Good photography is finding the balance between the two.

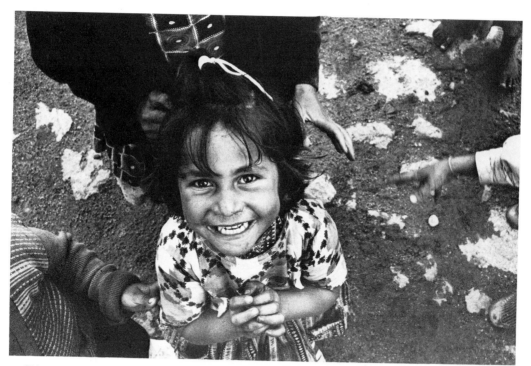

This delightful picture of a beaming gypsy girl in Turkey is a perfect example of a "grab shot" that worked. There was no time to think, much less to focus.

Enliven your travel shots with different perspectives. This photograph, taken through the window of a Tangier antique shop, captures the whole ambience of the scene without offending the dignity of the woman, a subject taboo to photographers in Morocco.

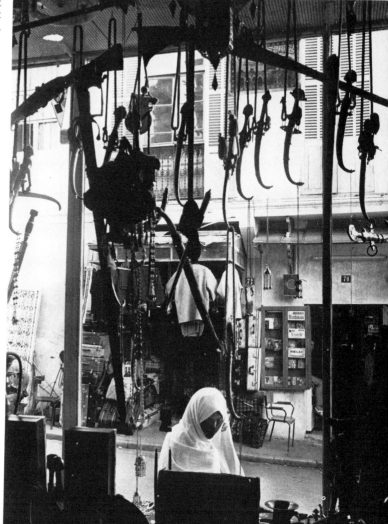

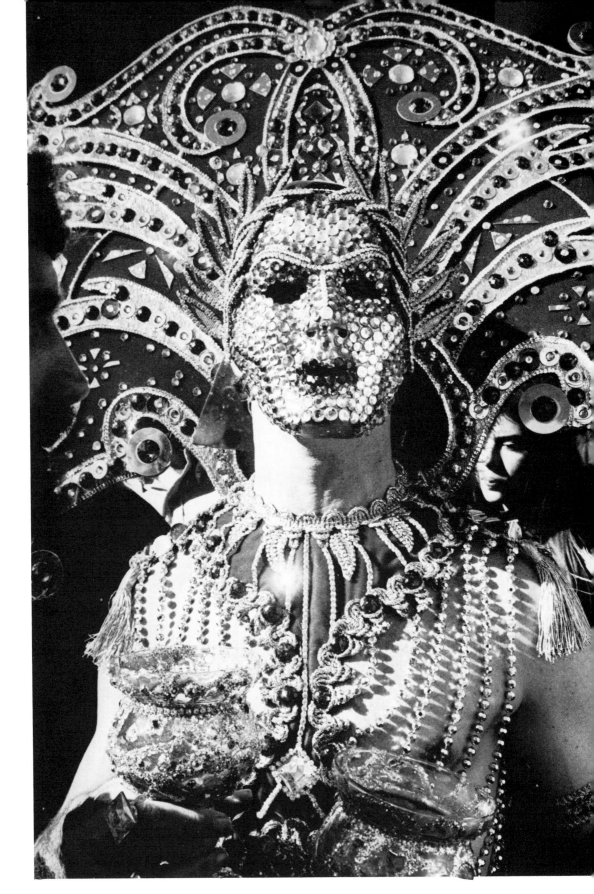

• Take lots of pictures of people. Quite often one returns from a trip with hundreds of photographs of buildings and scenery and almost none of the people. So load your camera and spend one day doing nothing but photographing natives of the land you are visiting.

• Always test new equipment before going off on a trip. You may have bought a defective camera, or one with an unsharp lens. Or you may be loading your film incorrectly, or forgetting to take off the lens cap. So shoot several rolls of film at home and have them developed. That way you'll familiarize yourself with all the equipment before setting off on an adventure.

• When you return from your trip and want to show your slides to friends and neighbors, make sure that you edit them first. Be strict, choosing only the very best. You will have a far more successful show if you have fifty excellent slides all by themselves instead of being mixed in with two hundred mediocre ones.

• When you shoot from inside a car, train, or plane, use a fast shutter speed to compensate for vibrations and prevent blurs. Hold the camera near the window to avoid reflections.

• When shooting on a beach, you may need to use various filters to cut down glare from water and sand. An ultraviolet filter is the most useful. Also, remember to protect your camera from sand and spray, and don't leave it sitting in the hot sun.

• When shooting landscapes be selective. Don't clutter your landscapes with too much detail. Choose one part of the scene as a focal point and compose your picture in relation to that.

• Pace yourself. Don't take a hundred photographs in one day and none for the rest of the week. Shoot a little bit each day so you get a full record of your trip. Remember, you are not only photographing the place you are visiting, you are photographing your life in that place.

Sometimes the graphic quality of black and white can be more effective than color. This sequined and beaded man, caught in the late afternoon sun, offers an unforgettable image which would have lost some of its power in color.

Heavy themes like death need not be treated in a somber way. Graveyard pictures are often cluttered and uninteresting. Here the angle, framing, and black-and-white separations produce an airy and light effect.

• Be creative. Stay away from static pictures that will wind up looking like postcards. Experiment by walking around a monument or building. Consider it from many angles and distances. In this way you will not only get the best possible photograph, you will also see the place you are visiting with greater intensity and clarity.

Up to this point we've mostly considered the technical aspects of pocket cameras and of photography in general. Of course, this is only an introduction. The subject is vast and can take a lifetime of study.

But for the amateur photographer who doesn't want to burden himself with too much equipment or too much information, what we've covered so far is enough for choosing the right camera and film and using it intelligently. For those who want to pursue the subject further, there is a bibliography at the end of this book.

Now let's turn our sights away from "technique" and toward "vision." In the second half of this book we'll talk about some of the more creative aspects of photography: how to see like a camera, how to shoot different subjects, how to have fun with photography in offbeat ways, how to present your pictures most effectively, and a look into the future of photography, where some amazing developments are taking place.

# part two:
# VISION

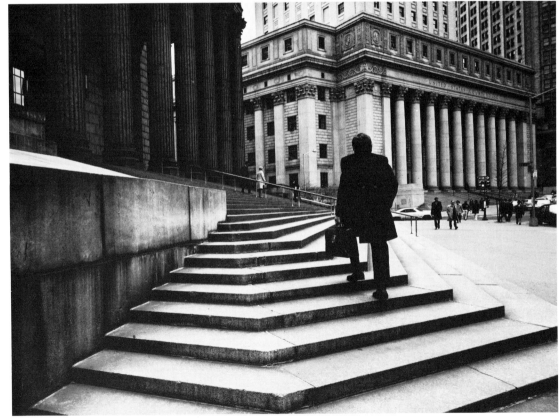

# Seeing Like
# a Camera

*The photographer's act is to see the outside world
precisely, with intelligence as well as sensuous insight.
This act of seeing sharpens the eye to an unprecedented
acuteness. He often sees swiftly an entire scene that most
people would pass unnoticed. His vision is objective,
primarily. His focus is on the world, the scene, the subject,
the detail. As he scans his subject he sees as the lens
sees, which differs from human vision. Simultaneously, he
sees the end result, which is to say, he sees photographically.*
—from *The World of Atget* by Berenice Abbott

Now that you have your pocket camera and film and understand the basics
of photographic technique—aperture, shutter speed, film sensitivity, use of
filters, etc.—it is time to look at the creative aspects of photography. You
may have complete technical control of your camera and still take pictures
which are cluttered, uninspired, or visually uninteresting.

The first thing to realize is that most of us are asleep to much of the
beauty and excitement in the world because *our eyes are lazy*. We have
learned to see the world pragmatically and have lost much of the sense of
wonder that the child and artist have.

---

A low camera angle and a wide-angle lens accentuate the architectural forms as this
silhouetted figure stands out in sharp contrast to the majestic columns of the gov-
ernment buildings.

I think that the greatest benefit to humanity offered by photography is that *it teaches us to see*. When we start to use a camera creatively, we become sensitive to form, detail, color, relationships, and all the qualities of the world around us. The camera is a tool of consciousness, helping us to wake up to the joy of *seeing*.

When you pick up a camera, your relationship to the world around you changes and your perceptions become fresh and stimulating. You go beyond even the pleasure of *looking at* images to the fun of *creating* them. You learn to see the world with fresh eyes.

Good seeing does not happen all at once, however. It comes slowly and with practice. It requires not only time, energy, and patience but openness and concentration. One must learn new "scanning patterns"—patterned ways of focusing our attention on things most meaningful to us, given our personal experiences, values, and tastes. Men and women have different scanning patterns, as do people in various professions. A cobbler will tend to look first at shoes, a barber at haircuts. A society lady checks status symbols while an architect sees structural form and balance. A thief sees easy scores and cruising police cars.

But all of this, as marvelous as it is, does not guarantee good pictures. Even if using a camera creatively helps you see the world more sharply and vividly, you still want to take better photographs. And what is required here is to learn to "see like a camera." You have to be able to imagine how the scene will look when transferred onto a two-dimensional piece of paper of limited tonal range.

How many times have you looked at your most recent photographs and been disappointed because they looked nothing like what you thought you were shooting? Is it because your camera was inadequate, or are you remembering the scene in a more beautiful way than it really was?

The answer is—probably neither. The problem almost certainly lies in the fact that you don't yet understand that the eyes see differently than a lens sees.

The eyes use *selective vision*. They go to the most personally interesting aspect of a scene and concentrate on that. The lens, on the other hand, makes no such discriminations. It just records everything in front of it, giving equal weight to every element. This is most true when you are using a wide-angle lens and the least true with a telephoto lens, where you make the lens almost as selective as your own vision.

The classic example of this is taking a picture of Aunt Bessie. Because she is the center of the photo, and is probably smiling, you concentrate completely on her. So much so that you don't notice that she is sitting in front of a window with a flowerpot on the sill. But when the picture is developed, we will see Aunt Bessie with a geranium that seems to be growing out of her head.

Another thing to remember is that film records ultraviolet light, which the eyes cannot see. So when you are shooting landscapes or views of the ocean, for example, ultraviolet light will put a "haze" on the horizon in the photograph even though you didn't see it yourself. It is here that your knowledge of filters (see Chapter 5) will come in handy.

Also keep in mind that you are seeing with two eyes but the camera has only one lens. If you want to get a closer approximation of what the lens sees, close one eye. In this way you can look at things two-dimensionally the way the photograph will appear on the film.

There are many aspects to this question of "seeing like a camera." There are some things you will just have to learn through trial and error with your specific camera. (Remember, not only are all brands and makes different, but each camera has its own little idiosyncracies.) The following tips will make sure that you avoid the most common errors. When these ideas become second nature and you incorporate them automatically, your pictures will immediately show dramatic improvement.

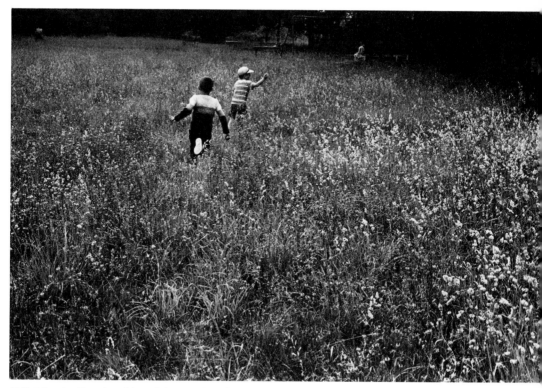

At first the view though a wide-angle lens may look like "too much," but with practice and experimentation you can learn to add wide-angle vision to your bag of visual tricks.

# VISUAL TIPS FOR BEGINNERS

## Framing

The world around us has no boundaries; it stretches out in all directions. "Framing" refers to the way we put borders on the world. In photography this means the boundaries of the picture. As you look through your viewfinder you are putting a limit on what's in front of you. Good framing involves selecting that portion of the environment which gives you a balanced photograph, with all the elements in harmony.

Many beginners have a problem deciding how to frame a subject, what things to include in the frame and what to leave out. If you have this trouble, ask yourself these questions: What aspect of this subject is most interesting? How can I best photograph *just that aspect?* Should I frame tightly or widely? Should I frame the subject dead center or should I put it to one side and balance it with other objects?

As you become more aware of what's involved in framing, let yourself become more imaginative. For example, shoot a whole roll of one subject, framing it differently with each shot. Don't be afraid to be unconventional.

A good principle to keep in mind is to *keep it simple.* If the center of interest is not easily recognizable, or if the other elements in the picture compete with the center of interest instead of highlighting it, then the picture will be cluttered and weak. There are times, however, when you will want to include a lot of details, but then make sure that you don't create chaos.

There are a number of tricks for calling attention to one specific part of the photograph. One is isolating an object from the rest of the picture. A dark subject—a black dog, for example—will attract attention if its surroundings are light in tone. Another is focusing sharply on the main subject and using the widest possible aperture so that the background will be blurred. A third method is moving the camera around until the subject is in bright light and most of the rest of the picture in shadow.

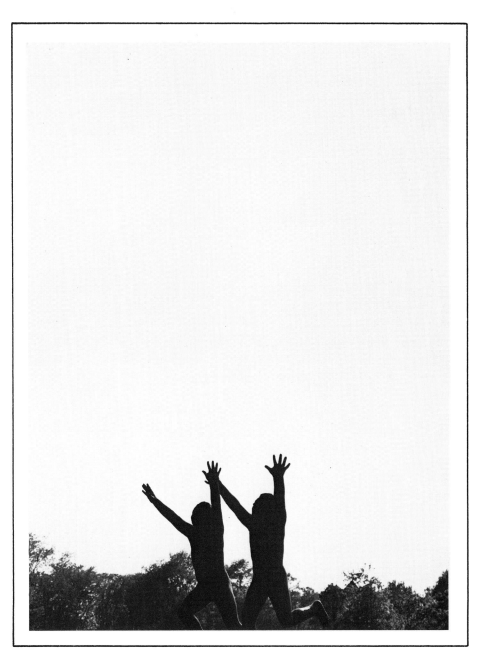

One of the basic rules in photography is to center the subject, but every rule has its exceptions. Here I used a lot of white space to highlight the feeling of expansion in the hands reaching up to the sky. In your photographs have respect for rules, but don't be a slave to them.

# Exploring the Subject

Amateurs tend to shoot something they like the minute they see it, from wherever they happen to be standing. While there is something to be said for spontaneity, it is also true that a little bit of thoughtfulness can open up many possibilities in a single subject. Don't be content to take a picture from a certain angle simply because you happen to be standing there when you see the subject. If you asked a dozen photographers to shoot the same object, you would have twelve very different photographs; probably from different angles and therefore with different perspectives.

When you find something you want to shoot, walk around a bit. Look it over from many angles. Try it up close, far away, and from a middle distance.

It is also important to look at the way relationships among elements in the picture change when you move the location of the camera or change to a longer or shorter lens. As you move closer to or further away from an object, it changes its apparent size in relation to other objects in the picture. This causes a shift in attention and importance.

In addition to capturing a moment of peak excitement, this picture works because of the perfect camera angle.

Here a combination of low camera angle, precise point of view, and wide-angle lens make this thirty-foot Picasso sculpture seem huge. You can enhance or diminish any subject through camera angle and choice of optics.

# Pictorial Elements

These are the qualities which make a two-dimensional sheet of paper look like a three-dimensional scene. There are a number of these elements to look for when framing your photograph and exploring the subject.

The first is *texture*. If you can get close to a subject and/or use super-precise focusing, you can capture the intricate surface quality of an object. This is very important if you want your photographs to provide the illusion of reality. In your daily life, even when you are not photographing, become aware of the textures of things; the way stone is different from wood or water different from skin. You will not only take more compelling photographs, you will wake up to the beauty of creation.

The second is *perspective*. The most obvious example is railroad tracks. If you shoot down the tracks, the film will record the same convergence that the eye sees. This "evidence" of distance gives the photograph a three-dimensional quality. Likewise, if you look down a row of trees, the one nearest you will appear largest. So keep alert for clues that show perspective in a scene, especially when shooting landscapes or anything at a distance.

The third is *outline*. If you see a building, person, or natural object in backlight or sidelight, the outline might be particularly bold or especially sensual. Keep alert for such striking outlines because they can add strength to your composition.

This is another example of patience at work. The visual patterns of the wall are extremely strong. I saw the man going down into the cellar and waited twenty minutes for him to emerge to capture him against this powerful backdrop.

The fourth is *color*. When you are using color film, if there are too many colors in a scene the picture may come out looking scattered and unfocused. There are two basic approaches to shooting color. One is to choose a single color as the dominant theme of the photograph and play all the other colors off against that, and the other is to make sure that all the colors which do appear are harmoniously balanced in the frame.

# THE "WHEN" AND "WHY" OF TAKING PICTURES

Everything we've said so far about seeing like a camera had to do with space. But there are two other aspects involved. One is time and the other is motivation.

## Time

The camera not only records an image, it also captures a moment. A photograph is a "slice of time." There are three methods for performing the operation of freezing the flow.

The first is the *pose* or fixed shot. This is when you shoot scenery or buildings, or when you stand a friend up in front of the camera and tell him to say "cheese." This is the most static type of photography, but it has certain advantages. You are very sure of what you are going to get, you have all the time you need for framing, and the photograph is almost always perfectly lighted and in sharp focus.

The second is the *perfect moment*. Obvious examples include the instant the golf club hits the ball, or exactly the right expression on someone's face (a gesture that might not last for more than a split second). Or you might turn your camera upward just as an eagle was flying in front of the sun.

The third is the *shotgun* approach. With this you take a very large number of photographs, many randomly, knowing that you are bound to get some of high quality. The point here is to capture scenes accidentally which a photographer would never be able to plan for. One professional photographer I know has taken as many as two thousand rolls at a single event!

---

Practice anticipation. I saw this little girl, dressed in white, approaching the black statues, and I waited until her position was perfect. The result is a provocative visual mystery.

# Motivation

In order to fix your priorities in framing, exploring the subject, using pictorial elements and color, and in deciding how you want to "slice" time, it is necessary to know what the purpose of the photograph is. You will want to change your composition, depending on why you are taking the picture.

For example, if you are taking snapshots, then all you probably want is a realistic likeness of the subject caught in a pleasing manner. So you'd place the subject in front of an uncluttered background, and shoot from a distance of from three to six feet away, placing your subject a bit off-center in the viewfinder.

But if you were a news photographer you would look for a strong, simple, eye-catching picture with dramatic highlights that sums up a human interest situation and tells the underlying story. You might even want to "clutter up" the picture with details in order to tell the story.

For a professional portrait photographer the aim is to take a picture that pleases and flatters the client. Here it is necessary to pay attention to lighting, making sure that it is diffuse and soft, and to camera angle, making sure that you catch the subject from his or her most appealing side.

A scientist uses photography to extend his scientific vision and aid his research. His photographs must be ultrasharp and objective. Scientists are now even using cameras to photograph things that "don't exist," such as subatomic particles that have no mass but only an electrical charge.

Advertising photography is geared to selling a product, so the emphasis here is on the prettiest subjects photographed with the most expensive equipment and by the most highly paid photographers. These people are absolute wizards, especially in the darkroom, where they can take a photograph of a wrinkled crone and make her look like Miss America.

Finally, we have "art photography," where the question of composition becomes crucial. Here photographers work with formal aspects of classical problems in aesthetics. Sometimes it even seems that they are not interested in the subject at all but only in the way the elements of a photograph abstractly relate to each other.

There are clearly many reasons why people take photographs, and in each case there is a different way of composing the photograph, a different way to "slice" time. In each case you must remember why you are taking the picture and use your camera accordingly.

When you look at a scene it is not your eye that sees but your brain. Your vision is colored by memories, past perceptions, associations—your entire conditioning. But the camera is only a machine, subject to the laws of optics. It records light, not feelings. So if you want to get not only the neutral details of a scene but the "feeling" of the scene, you must learn to translate your way of seeing into the ways the camera sees.

But in doing this don't get so caught up in figuring out what makes a good picture that you forget to have fun taking the picture. Except for those people who earn their living as photographers (and sometimes even among them), it is important to have a good time when taking photographs. Photography should always be a recreation, never a chore. This sense of freedom and relaxation is perhaps the single most important ingredient in taking good pictures.

# The Subject

After all the preliminaries, we now come to the thing which is the whole point of photography—the subject. When áll is said and done, every photograph has to be a picture of *something*.

Since everything that can be seen can be photographed (and even some things that can't be seen, such as molecules and distant galaxies), there are millions of possible subjects.

But more than 90 percent of everything people take photographs of fall into one of ten categories. These involve such subjects as the family, children, pets, etc. And each of these classes of subject requires special considerations, sometimes technical, sometimes psychological. If you can master a few simple tricks and insights into these subjects, you will find yourself approaching everything with confidence, and you and your camera will be a highly trained team.

From there you can go on to perfecting your technique and developing a personal style. Also, you can begin to try more exciting, experimental approaches by using your camera as a way to explore the world around you.

The introduction of pocket cameras has made much more of the world more easily accessible than before. With these lighter, more compact models (especially those with automatic features) you can carry a pocket camera into situations where you might not go with an expensive, professional-looking camera.

---

Babies and young children are unpredictable subjects. Photographing them requires a great deal of patience and understanding. Choose familiar surroundings and keep the atmosphere calm. Even under these conditions try to keep your photo sessions to about fifteen minutes.

In all photographs involving people, having a small, inconspicuous camera is a great advantage. This is most clearly seen in candid photography. Many people tend to freeze when confronted by a large, serious looking camera and will act more natural when confronted by something that looks like it only takes snapshots. Some of the pocket cameras (like the Pentax Auto 110) are so small that they practically fit into the palm of your hand. So they go unnoticed, even by the people whose picture you're taking.

Following are the most popular subjects among photographers. Let's look at some special ways of photographing them.

Pentax Auto 110
Weighing only six ounces, including lens and film, this camera shows how far miniaturization can go.

# CHILDREN

It has been said that more pictures are taken of children than any other single subject. Whether or not that is true, children are very high on the popularity scale among photographers.

Children are marvelous subjects, energetic and uninhibited. Unlike adults, they have not yet learned to mask their feelings. Their faces and body language mirror their moods.

But children can run you ragged! They move around a lot—and quickly! So it's important for you to be just as quick, to learn the knack of shooting almost without thinking. You must be ready to catch the moment when it occurs, for it is only there for a split second. It requires a kind of zen photography.

This child ran me ragged and her constant motion made focusing impossible. Finally, I asked her to play a game with me. I told her to do anything she wanted, so long as she stood in one spot, the newspaper.

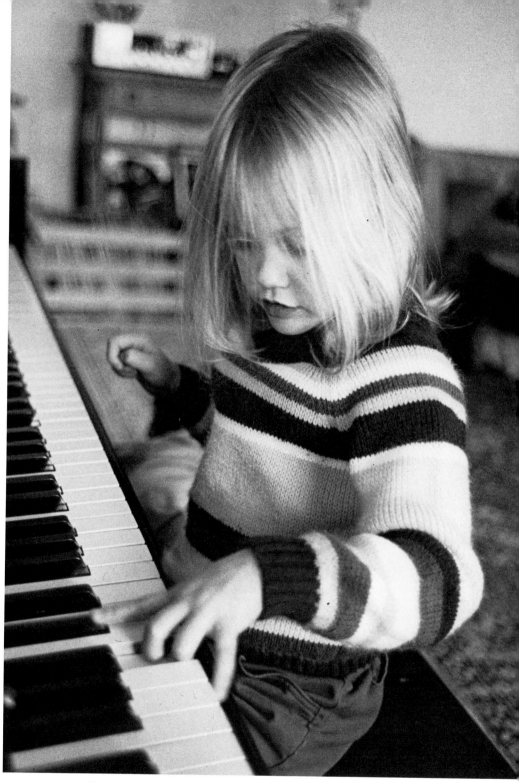

The most difficult thing about photographing children is getting them to keep still. The best thing to do is to have the child get involved in something interesting, to the point of forgetting that you are there. And when your subject shows just the right expression, press the button and capture a priceless moment.

Self-discovery is a process of endless delight for a small child. Be ready to capture these priceless moments.

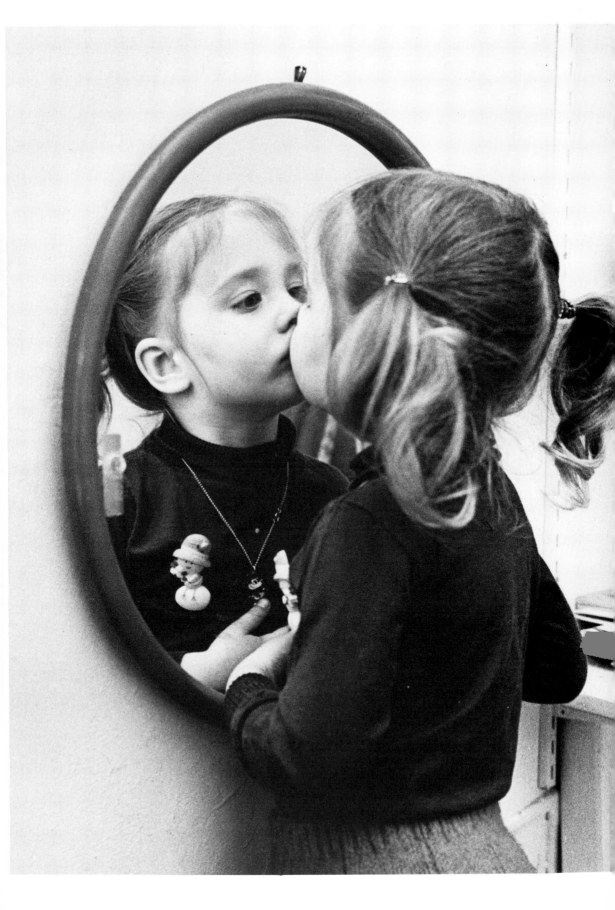

Children hold an inexhaustible interest for photographers, whether in studio work, portraiture, or photojournalism. This photograph is a rare instance of my posing a child, using cloth strips as a prop.

Kids don't care about sex roles. This little boy pushes a baby carriage while wearing a hard hat. This kind of incongruity is always captivating.

You must also learn to anticipate good pictures. Sometimes this is easy. For example, if you see a bunch of children in a playground, all you have to do is sit nearby, figure out lighting and shutter speed, and wait. After a while the photographs will almost suggest themselves as the children act more freely in front of you. Then just lift your camera and shoot.

It is a good idea to try to get "inside" the child's mood, to get a sense of what he or she might do next. Photography can be a means of helping you to become sensitive to others.

When photographing children at play, it is a good idea to wear old clothes that give you the freedom to crawl around, roll in the grass, and really get down to the child's level. The more you can become one with the child's world, the better photographs you will take.

Of course, you can also try to get children to actually pose for you, and occasionally you will get a sweet shot. But by and large the best thing is to leave them alone, let them be themselves, and just record it. Don't be afraid to dedicate a few hours to photographing children, and be sure to shoot several rolls of film.

One good trick, if the child is old enough, is to give him or her a loaded camera to take a picture of you. Since kids love the idea of taking pictures, this is a great game to get them comfortable around a camera. And you'll be surprised at what really good pictures they sometimes take.

A trap that many photographers fall into with children is only taking "pretty" pictures. Children are not little angels all the time, and you should not neglect the other sides of their personalities. Photograph children when they are sad and withdrawn as well as when they're happy and full of fun. This is also a way of teaching them that all aspects of their personalities are acceptable.

By and large, try to eliminate anything artificial or uncomfortable from any shot with children. Use natural light when possible and ordinary surroundings. Attempt to capture the innocence, freshness, enthusiasm, and energy of the child. That's the essence of child photography.

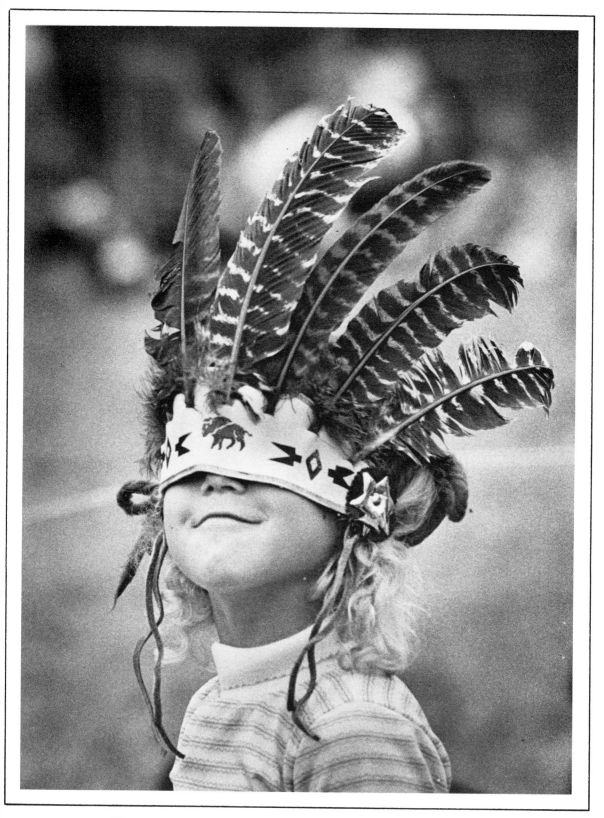

When photographing children, stay away from the cliché poses of "little angels" and show them as they really are: curious, energetic, and mischievous creatures of a thousand faces.

# 📷 THE FAMILY

Most photographers begin taking pictures by using their family as subjects. The pictures you take of your family at home are going to be among your most successful because you are working with people and situations you know well. Also, you are very likely to have your camera very close at hand.

The major difficulty with photographing the family is that taking the picture becomes an event. People stop what they're doing and stand stiffly, staring at the camera. These photographs have neither the power of formal portraits nor the charm of spontaneous shots.

The best pictures will almost always be when the members of your family are unaware that you are photographing them. Take the picture while they are absorbed in some activity. If they notice you, tell them not to stop what they are doing, and when they have resumed a natural position, capture that intimate moment.

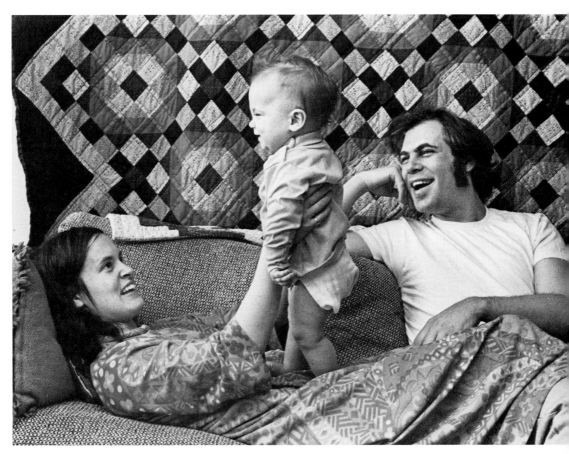

When photographing families, the most important thing is for the people to be relaxed. In this case I had dinner with the family, and by the time we gathered in the living room they forgot my presence, so my picture caught their real intimacy.

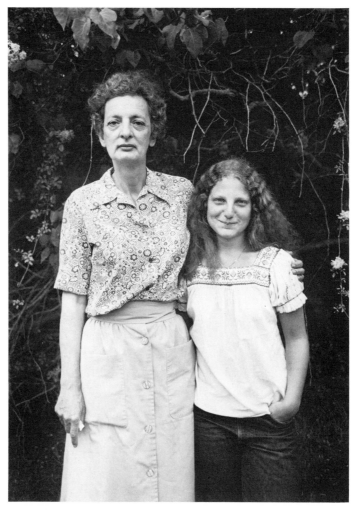

The posed portrait can reveal volumes about the subject through body language, expression, and detail. Here, mother and daughter show up in sharp contrast. The mother is more stiff, reserved, and conservative. Her daughter is about to burst out laughing and is dressed in a more lively manner. In this split second two lifestyles are revealed.

Try to become invisible. This doesn't mean that you should creep around the house but that you should be as relaxed as though you had no camera. Having a small simple camera is a great advantage. If you don't call attention to your camera, the chances are that others won't either.

Another thing to do is to get someone's attention; the instant they turn to you snap the picture. This is a perfect technique with automatic cameras, where you have no focus or aperture problems. But don't do this if you have to use a flash; there's nothing more annoying—and potentially damaging to the eyes—than to have a flashbulb go off when you are not expecting it.

One of the main things to remember in family portraits is capturing not only the people but their relationships. A shot of a mother looking at her child lovingly, or two brothers wrestling, or of a husband and wife giving each other a knowing glance—all give the photograph high dramatic quality and deep human interest.

Try not to let your familiarity with the people and the surroundings blind you to their photographic value. That old chair you've sat in since you were a child has a special quality, a "mood." Look at it in different kinds of lighting and use it as a prop for members of your family. By showing your grandparents, parents, yourself (using a timer), and your children all seated in the same chair, you give a strong impression of the continuity of the family.

On the other hand, be aware that just because you like a certain object doesn't mean it will automatically make a good photograph. Even when shooting for the family album, you should pay attention to framing and cluttered backgrounds. You may have a hard time thinking of all the items in your den as "clutter," but remember that the camera lens has no sentimental attachment to anything.

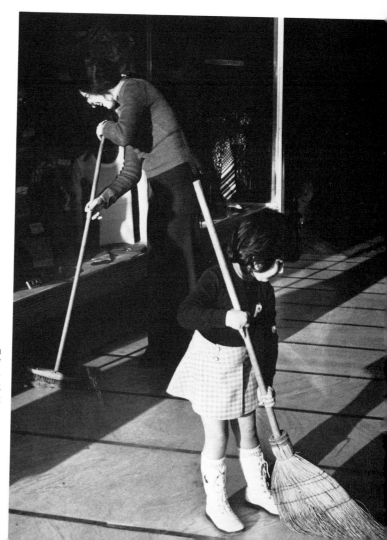

The charm of this photograph lies in the way it captures the mother/daughter relationship. Instead of aiming for the isolated shot, try to look for connections between people that tell a story.

# 📷 PSYCHOLOGICAL PORTRAITS

Taking portraits seems easy: Simply have someone sit or stand in front of a camera and then snap the picture. The technical side of portrait photography also appears simple. The subject is not moving and you are shooting from close up, so you can focus, control the lighting, and frame exactly as you wish. (You should make sure, of course, that the light is soft and flattering and that the background is not cluttered.)

But the real question in portraits has to do with capturing the subject's character and feelings. Many of the sensitive studies done by Richard Avedon, which are often published in the leading fashion magazines, show how the camera can peer into a person's deepest self.

For a commercial portrait photographer the main thing is to get a flattering likeness, but for the artist and the amateur it is more important to get an intimate, expressive photograph that goes deeper than just a pleasant smile.

Photography is especially suited to portraiture. In the old days portraits were done in paint; a skilled painter could use his brushes to capture many subtle nuances of feeling. But the photographer can record these same feelings directly and instantly. He or she can explore many different moods and feelings, experimenting with different poses, angles, framing, and lighting techniques.

How, then, does one go about creating a sensitive psychological portrait? Professional photographers state that the single most important factor is establishing good rapport with the subject. Think of the shoot as a collaboration in which both must cooperate for the best effect.

Put the subject at ease and gain his or her confidence. The best way to do this is to appear relaxed and confident yourself. Play soothing music, serve refreshments, and do whatever you can to make the person feel welcome, comfortable, and important.

Also, try to shoot in locations where the subject is most at home. Take pictures of the subject at his or her desk or at the kitchen table sipping coffee. Photographs like this are exciting because they show not just a person's face but something of their way of life.

If you have an automatic camera or a camera with adjustable shutter speeds, shoot at as fast a speed as possible and have the person do things that involve fast movement, like dancing. If you can freeze someone at the peak of some distinctive, sharp movement, you will capture expressions that don't arise when people are sitting still.

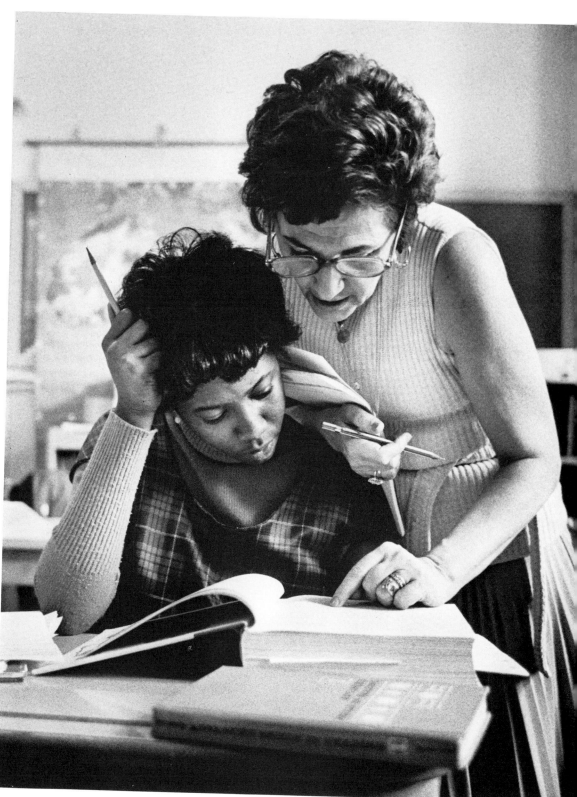

This is an almost perfect photograph of its type. The lighting, composition, and human interest all combine to tell a story of dedication and respect between two human beings — teacher and student.

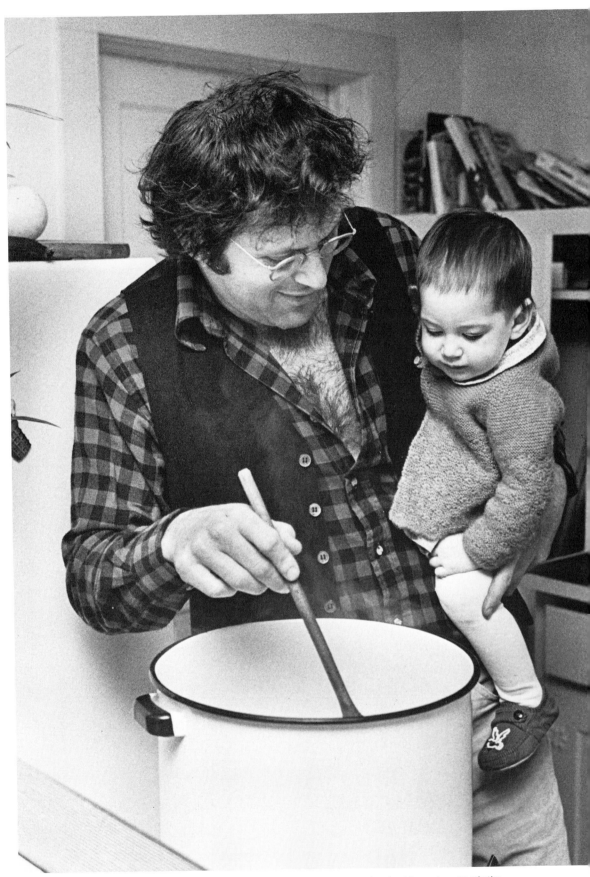

Times have certainly changed! Dad is now in the kitchen showing his son how to stir the soup, while Mom is out working. Even the simplest photograph can show complex social roles.

This pensive moment was caught as this schoolgirl was staying late practicing her typing. Learning basic skills can be made more enjoyable by using photographs to encourage children in their work.

The best lens for portraits is a normal lens; a wide-angle lens will distort. But you can also experiment with a telephoto lens because it tends to make the face look flatter, thus muting the features. Fashion photographers routinely use lenses longer than 100mm in their work.

Fashion photographers, by the way, have established an entire routine for coaxing their models into distinctive poses, and you might take a tip from the pros. If you can afford it, for example, having motor-drive film forwarding allows you to capture very quick, subtle changes in expression. They also give their models time to prepare, often helping them to relax with coffee or a drink and then playing music during the shoot. With different music you can create different moods. And, finally, fashion photographers all use a "patter" in which they continually encourage and compliment the model, urging him or her on to more dramatic expression.

Soft, evenly diffused light and a relaxed subject combined with a simple background yield a psychological portrait that tells us something about how the subject feels.

# ◉ ANIMALS

Animals are, like children, an ideal subject for photography. They have what professionals call "instant viewer appeal." We are all familiar with a shot of a cute kitten and an adorable puppy, subjects so winning that they even compensate for poor technique.

The easiest subjects to begin with, of course, are household pets. They are nearby, friendly, familiar, and likely to respond to direction. When doing this kind of shooting, the best thing is to give the animal some space and yourself some time. Instead of posing your pet in some artificial manner, let it move around freely and try to capture some characteristic bit of behavior or expression.

The best photographs are those that show the animal against an uncluttered background. It is also a good idea to frame the picture very tightly so that the animal does not get lost in a sprawling view of a large scene. For this, a telephoto lens is almost indispensable. With a regular lens you will have to approach the animal too closely and will probably disturb it.

Most 35mm and the best 110 cameras have interchangeable telephoto lenses; the better 110s have a built-in telephoto, operated by flipping a switch. A few of the instant cameras have telephoto lenses (but none of the 126s now on the market). If you are an especially avid fan of animal photography, you should probably invest in this particular accessory.

Daylight is the best lighting for taking pictures of animals since it allows you the freedom to follow the pet around and shoot from many angles. As usual, try to avoid direct sunlight and look for cloudy/bright days when the light is diffuse. If you use a flash, be careful of red eye (see page 63), which happens with animals as well as people. The best way to avoid red eye is to have a flash that is set to one side of the camera. Also, you can shoot from farther back or wait until the animal is not looking at you.

Second to pets, taking pictures of zoo animals is the most popular form of animal photography. This is not so easy since the animals are either caged or are away behind a ditch or barrier. They also might be asleep.

Using a telephoto lens is helpful, but it is just as important to take time and plan the shot. Observe the animal for a while to see how it moves around its cage or enclosure. Pick a spot where you know it will approach, set your focus and aperture (unless you have an automatic or a camera with a fixed lens), be ready for the next time the animal passes there, and then just shoot. You will have a photograph that is technically excellent but unpredictable in content. If you shoot enough of these, you are guaranteed at least one masterpiece.

The most important thing in the zoo is avoiding cage bars. To get around this problem, either place your lens so it points between the bars (being careful with bears and large cats) or choose a wide aperture to narrow the depth of field and then place the camera close to the bars so as to throw them out of focus—and even render them invisible in some cases.

With some animals it might be a good idea to take a sequence of action shots in order to capture the way they often show off for visitors. Remember: Don't always be satisfied with a single static shot.

You need a well-trained and good-natured animal for this kind of stunt, but the effect is very funny and well worth the trouble.

This picture perfectly illustrates the idea of tonal separation, which simply means placing a dark object against a light background. If the cat had been standing against a black wall, there would have been no impact at all to the picture.

# ◻ CANDIDS

Today's small and easy cameras are a great blessing in this area of photography. With the full-sized 35mm SLR, the camera is often intimidating and strangers are likely to get nervous and shy away. But with these new cameras it is much easier to catch people in candid postures and gestures.

Taking candid photographs of strangers in public is perhaps the most psychologically difficult task for a photographer. The major difficulty, I believe, is fear rooted in insecurity. We are anxious about what might happen. However, the more we worry about what might occur the greater the fears become.

Street shooting *is* unpredictable. Some photographers also think it is undignified. And on occasion it can even be risky if a hostile passerby takes offense to what he or she considers an invasion of privacy.

Candid street photography requires a temperament of calmness, assertiveness, and self-assurance as well. It also involves a great deal of patience and determination. And it is surprisingly hard to get a really good shot; things are much more haphazard in street photography. You can walk the streets for hours and not find the right subject to photograph. However, street photography is extremely rewarding because there are few photographs as charming and disarming as good candids.

The advent of the automatic camera has been a great boon to candid photography because you can just "point and shoot" the instant you see something interesting. But if your camera has manual controls, here's a useful trick. Load it with fast film, like Tri-X, preset the f-stop for existing light, and set the focus for ten to twelve feet (the average distance at which you will take a candid). Then you can shoot anything in that range without worry.

I used a wide-angle lens to include as much information while keeping the composition strong and clean. This street scene shows a block party in Manhattan before the various stands and amusements were set up.

The lively energy of a good candid shot is far superior to the static posture of most posed photographs. But it is necessary to get friendly with the people you are shooting so they will relax in your presence.

The whole attraction of the topless bar is brought out in this photograph of a man trying to get a free peek. This shows that you can get very suggestive photographs without showing anything explicit.

There are two basic approaches to candid photography. The first is to actually let people know what you are doing, and the second is to go ahead and do it without permission. The second is riskier and involves some ethical questions, but it often yields the more compelling photograph.

If you let people know what you are doing, try to be as honest and open as possible. Don't be embarrassed to approach a person or group of people and say, "I really find you interesting. Do you mind if I take a photo of you?" They may think you want them to pose, but tell them that you'd like them to continue with their activity. A first you will see them sneaking glances (and that could make a good photograph in itself), but after a while they will forget you are there and you can capture them in some kind of characteristic and colorful behavior.

If you are not going to tell people you are shooting them, there are a couple of tricks to keep in mind. The first is to *pretend that you are photographing something else*. Use a wide-angle lens and avoid eye contact with the subject. By using peripheral vision to estimate the focus, you can get good candids from only a few feet away and the subject will be none the wiser. Gaze into the distance and pretend to be photographing something in the background; you will often capture expressions of people who are looking right at you but don't know they are being photographed.

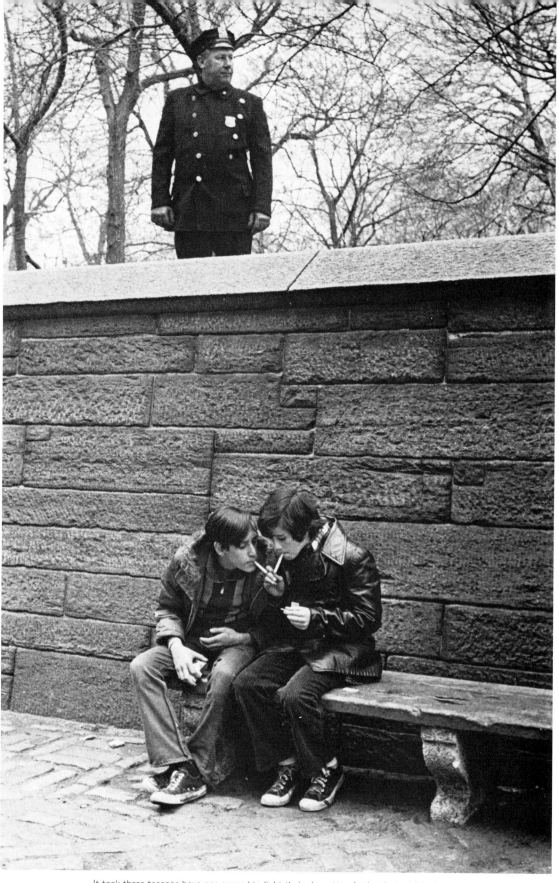

It took these teenage boys one second to light their cigarettes. In that instant I had to see what they were doing and understand their relationship to the policeman standing above them. To capture this kind of ironic statement you must not hesitate an instant.

The second trick is to do your photographing during some kind of public event—a street fair, parade, or political rally. At times like these, people are so crowded and distracted that they are less likely to notice a photographer or care about one.

One of the reactions you will run into is that people will say, "I'd love to have you take my picture, but I'm so unphotogenic." Tell them that there are, indeed, people who are so totally photogenic that they can be shot from any angle and still look good but that they are rare. Everybody else has their good aspect and bad. Then encourage them by telling them that you are going to look for their most handsome or most beautiful "face." Now you can take your time trying different angles to find the most flattering shot.

It is also helpful to try a bribe. If you first take a person's photo with a Polaroid and then give them the picture as a present, they will usually be more than happy to let you shoot them with your 110, 35mm, or Instamatic.

Relationships can often tell a story better than a single image. Here we have the social and economic relationships of these five people expressed more fully than would be possible in a lengthy essay. Notice also that the man's hand on the woman's back serves as the central visual element in the photograph.

Even in the most cluttered and chaotic scenes, you can always find an angle and moment to rescue a strong and simple photograph.

In all of this, remember the legal aspects. You can take and display any photograph taken in public (which includes sports stadiums, hotel lobbies, etc.) if it is not being used for commercial purposes and if it is not printed with a demeaning caption and/or in a bad context. Photographs taken in private or taken for possible sale require that the subject sign a model release before it can be displayed. These releases may be obtained at any camera store.

If you are interested in candid photography in a serious way, practice it often. Henri Cartier-Bresson, the master of the candid photograph, takes a daily morning walk, cameras loaded and ready. He tries to be as unobtrusive as possible. As he puts it, "Let steps be velvet but your eye keen; a good fisherman does not stir up the water before he begins to fish." What he means is that one should avoid calling attention to oneself. Cultivate a quiet, nonthreatening manner and dress conservatively; look ordinary, so you blend in with the crowd.

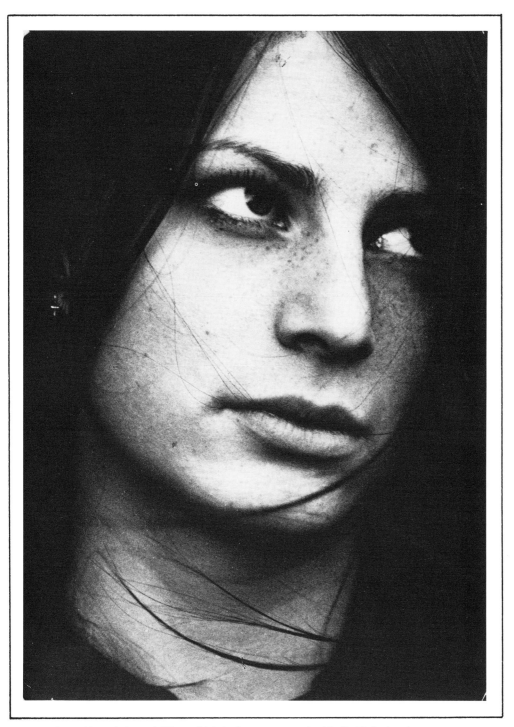

I was able to photograph this candid shot of a woman on a street in Stockholm by using a medium telephoto lens, which allowed me to shoot her without her knowledge.

# 📷 WEDDINGS

A pocket camera is ideal for capturing the intimate, personal moments in a wedding celebration. Some very fine shots can be taken without the loss of spontaneity and naturalness which is apparent (yet necessary) in the posed shots put together by the wedding photographer. Present yourself as a personal friend of the family who will provide extra special photos that only a friend could capture.

A wedding is a one-time event, so make sure that your camera is working properly and that you have plenty of fresh film and batteries. This is one time *not* to economize.

Even though the official photographer is getting all the standard shots (the bride cuts the cake, etc.) take pictures of those too. With your small, flexible camera you can get angles on these poses that will inject spontaneity into an otherwise stiff photograph. Try slightly unusual angles and dramatic lighting.

If you really want to be the hit of the wedding, in addition to the shots you take with your 110 or 35mm or Instamatic, do a bunch of Polaroids or Kodak Instant-Pictures and then tack these to a wall so that people can see the progress of the wedding as it goes along.

But don't go overboard. Because those photographs are to record a very special event, it is important not to take unflattering or distasteful pictures. With that in mind, be as creative—even as zany—as you like. If the bride's father gets tipsy and puts on a funny hat, don't miss it.

There are some tricks to consider. One is covering the lens with a gauzy fabric to give a soft, romantic effect; this is especially good for pictures of the bride. Also, when shooting her don't just look for the happy, extroverted pictures, but wait for moments when she is pensive. After all, she is taking a step that will change the rest of her life, so in addition to the celebration there is also a kind of thoughtful quality that should be captured.

Move around the reception grounds looking for the details and incidents that make each wedding unique. Keep your eye open for revealing expressions on people's faces. For example, see if you can capture the moments when the bride and groom look at one another when they think they are not being watched. If you can get an especially tender expression, they will thank you for it and even forgive you for "spying."

For weddings color is almost always required, but if you are shooting in a dark house or church, or outdoors at dusk, a roll of fast black-and-white film would not be out of place. You can get effects with black-and-white that are not possible in color.

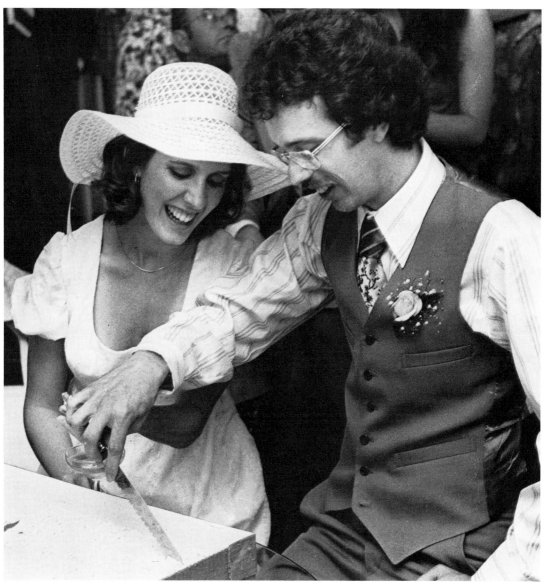

This candid Polaroid may not have the quality or elegance of a professionally posed shot, but it captures an intimate moment of warmth and charm, providing a picture that this couple will enjoy for the rest of their lives.

# 📷 SPORTS

This is one of the more complex subjects. To deal with it we can break it down into four parts: team sports, solo sports, indoor sports, and outdoor sports.

In all of these the single most important question is speed. You will almost certainly be shooting someone who is moving very quickly (except in a chess game) and you'll want to freeze the action as perfectly as possible. Most professional sports photographers rely on the combination of a fast shutter speed, small aperture, and fast film. Shooting with ASA 400 film at $\frac{1}{500}$ of a second and f/16 is the standard setting.

If you have a camera with a fixed shutter speed, however, you may get the same result by "panning." Follow the action with the camera, moving it from right to left, bottom to top, or whatever direction is necessary, and then press the shutter release when your motion matches that of the athlete's.

One helpful accessory in sports photography is the motor drive or auto-wind to automatically advance the film as you shoot. With the best motor-drive cameras you can click off a sizzling 3.5 frames per second.

If you want to select out a person or activity and blur the background, the best thing is to use a wide aperture for shallow depth of field. If your camera has a fixed opening, then look for those shots that are improved by some blurring. For example, if you blur horses in a race it gives gives the impression of motion.

When shooting solo sports you should aim at capturing not just the person but the whole mood of the activity. Choose your viewpoint carefully. A side-on shot may give a sense of dynamic action, while a head-on shot might show the concentration in the athlete's face.

It is a good idea to prefocus your camera to catch fast action. Point it at a place you know the athlete will pass and then wait for the peak of action. There is a moment when the performer's movement reaches its climactic point; shooting at precisely that instant will give you the most dramatic photographs. For example, there is a split second when a pole-vaulter hangs in the air just before dropping, and that is the shot to shoot for. A telephoto lens is a must when shooting sports events, since the spectators are usually at a distance from the players.

As with weddings, don't just take pictures of the "up" moments. Try to catch people when they are about to begin an event, or when they have just finished. Locker room shots can be very moving, capturing facial expressions of people who are preparing and psyching up or who have just finished a difficult ordeal.

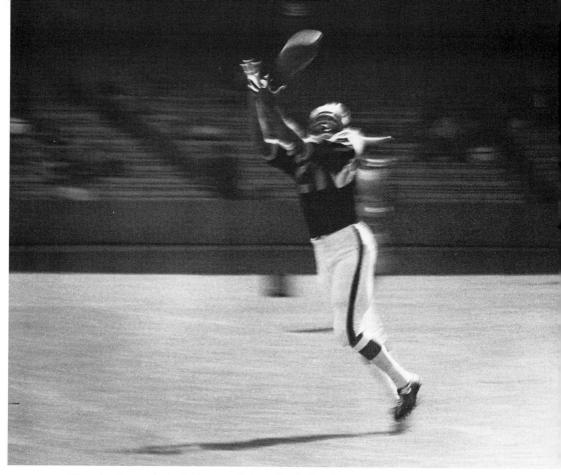

When shooting sports, try to give your photograph a feeling of motion by "panning" the camera to follow the moving object.

With team sports, relationships among people come into play because this is the essence of team competition. So capture moments of camaraderie among teammates or rivalry between opponents.

Knowing the rules of the game will help you anticipate the action. You can have a sense of which way the players will move and be there to shoot them right in the midst of the action.

If you are following a race, record as many different parts of it as possible. Say you are shooting a swimming meet. Capture the swimmers on the block, then as they dive, as they hit the water, as they are swimming, at the finish line, and finally as they pull themselves out of the pool. This kind of continuity will give you a dramatically satisfying record of the event.

It is very important to "see like a camera." Don't be lured into shooting a scene when the players are in the distance; all you'll get is a picture of tiny figures in a vast expanse. Pick out those elements that are most visually compelling and zero in on them. You might also consider going to practice sessions where you would be able to mingle among the athletes when they are more relaxed and less worried about making a mistake.

Indoor sports demand a good deal more from the photographer. Many arenas do not provide enough high-quality light, and some have spotlights which create light bubbles on the film or simply overexpose it. The larger apertures required in dimmer light reduce the depth of field, and slower speeds make it difficult to freeze action. A flash is the best bet for subjects that are not more than fifteen or twenty feet away. Beyond that you will have to figure out each situation as best you can.

# SELF-PORTRAITS

This is a largely overlooked area of photography. Most people never think about taking their own picture—which is odd, since most of us have a narcissistic streak.

There are several ways of doing this. One is to put the camera on a tripod or rest it on a table, focus on a spot where you'll be standing, set the automatic timer, and walk over to pose for the picture. With automatic focus you can also hold the camera at arm's length, estimating the angle of the lens so that it points at your face, and just shoot. Try this with a friend and get a great picture of the two of you cheek to cheek.

An interesting experiment is to take a picture of yourself every week or month for several years. Take it with the same light and at the same distance. See how you change as you age, how your moods alter. This is a kind of photo diary that can bring a person a great deal of gratification and insight.

I had a student several years ago who was very shy and thought she was plain. I got her to start taking self-portraits, and after a few months she came into class and exclaimed, "You know, I'm pretty!" By taking her own photo again and again she got over her self-consciousness and was able to see herself clearly. She discovered for herself (the most important person) that she was good-looking after all.

The self-portrait can be extended beyond pictures of just your face. You can take photographs of your shadow on a wall, your reflection in a window, or photographs of your room, favorite chair, etc.

You can use the camera as a tool of self-exploration and discovery.

# ◻ ABSTRACTS

Within each of us is the ability to pick out and enjoy striking patterns of light and dark. But most of us do not exercise this faculty and it gets lazy. We think that abstractions are something only for artists or philosophers.

But the camera can help us train our eyes to see beauty and meaning everywhere. Consider the way light filters through trees and throws shadows on the ground, or the way buildings stand out against a sunset.

Early morning and late afternoon provide the best light for strong shadows and sharp patterns. As you walk down the street, along the beach, or through the woods, begin to look for anything that catches your eye, not for specific subjects, but for sudden splashes of color or design.

Make your eyes sensitive to the textures of things, their shapes and forms. Get in tune with their visual impact. If you are looking at a flowerpot, for example, don't think about its function but about the way it stands against the wall and how sharply its curves define it.

You can also blend abstract and concrete elements. I once saw a photo of a butterfly wing. For several minutes I was aware only of its color and shape and appreciated it as an abstract photograph. But then, all at once, I realized what it was and could enjoy the way the photographer had tricked me into seeing a familiar object in a new way.

An ordinary event, a young girl floating in a lake, has been transformed into a beautiful image of light and shadow. This shows that pictures of children can also be mystifying.

# Special Effects with a Polaroid

There is now a wide range of abstract effects you can get with Polaroids. The emulsion of a Polaroid SX-70 picture remains fluid for the first few minutes it is developing. Using a photograph that you know didn't come out too well, take a blunt tool, like a wooden palette knife, and push the emulsion around by pressing on the film surface. Work gently at first. Once you get the knack of this technique, you can work with photographs that *did* come out well; you will be able to turn really good photos into extremely creative ones. There are no rules for this, so treat it like a game. Have fun and learn as you go along.

You can peel the backing off a Polaroid picture after it has developed and then wash the white emulsion away with absorbent cotton. (Be sure to use protective gloves or the emulsion will burn your fingers.) Now paint different colors on top of the remaining emulsion, using anything from house paint to nail polish. When you turn the picture over and see the front, it will have been transformed into something really strange and wonderful.

Another interesting technique is crackling the picture. Hold the picture about four inches from a match or cigarette-lighter flame as it is developing and it will come out as a photograph with thousands of tiny lines running through it, like a very old vase, giving it a distinctive mood.

A nice idea with any print you especially like is to have an enlargement made. Many people don't think of blowing up an instant camera print. But you can have it done easily: Just send your print to the camera company directly or through your drugstore.

# ▣ POSSESSIONS

There are two reasons for photographing your possessions. The first is just to make a good photograph of a treasured object for your own personal enjoyment. In this case you should pay attention to all the tips we've discussed so far for getting pleasing photographs.

But if you are photographing possessions for insurance purposes, you should take a different approach. Here you are not interested in aesthetics but in accuracy. You want a photograph that provides a clear and objective record of what it is that you own.

For large objects, such as automobiles and certain pieces of furniture, make sure you shoot them from several sides. The light should be bright but not direct to avoid glare and harshness.

Keep a log listing all your items, with brief descriptions, serial numbers, dates and places of purchase. In a separate envelope keep all purchase slips, canceled checks, credit card vouchers, etc. Key the photographs to the entries in the log. Keep everything in a fireproof location; a safe-deposit box in a bank is best.

When photographing small objects, use a closeup lens if your camera has one. If you are shooting anything with glass covering it, make sure that you do not get a glare from the available light or a bounce-back effect from a flash.

The more you learn about shooting one type of subject, the better you will be with other types. For example, when you have developed an approach for shooting portraits, candids, and animals, you will find that you can also approach unfamiliar subjects with a greater degree of confidence.

It isn't possible to discuss all of these in this book, but part of the fun in photography is learning as you go along. Also, there are specialized books on the subject of "the subject"; the Bibliography will give you some ideas for other themes and lead you to specialized works on specific subjects. (For example, there are dozens of books on photographing children.)

In the next chapter we are going to leave behind all questions of technique and content and venture into an area that too often gets overlooked—the fact that, first and foremost, photography should be fun. And while it is true that knowing a few of the rules will help you take pictures, you have to break the rules from time to time to keep yourself from getting in a rut.

# Fun Photography

If we remember how photography began, it sometimes seems that things have become very complicated. The art and science of photography have progressed incredibly, but many people think that we have paid a price for that: the loss of simplicity.

Reading through even the simplest book on cameras, one is faced with technical problems of film, shutter speed, aperture, and focus. And then there are further discussions of lighting, framing, camera angle, not to mention extra lenses, filters, and a whole assortment of accessories.

Most people find all of this intimidating. And there is a popular prejudice that you can't take really good pictures unless you've mastered the ins and outs of all this theory and paraphernalia. Because of this, so many amateurs develop a kind of inferiority complex about their work.

This question can be argued back and forth forever. In this book I have tried to show that one needs both the technique and the spirit of photography. But this chapter is devoted entirely to the *fun* of photography, so I'm going to suggest things that not only don't take into account the rules of good photography but even break them!

We've spent some time discussing the limits of photography. Now let's go beyond that into a realm of play. Here are some suggestions for unusual experiments with your camera.

---

Photographs are easy and fun, and a darkroom is not necessary. Simply place objects on a piece of photo paper in a darkened room and turn on the lights for one or two seconds. Then put the paper in a lightproof box and send it to any photo processing lab. The resultant image will be a high contrast and dramatic one.

# CREATIVE PICTURE-TAKING

## A Day in the Life

Take a whole day and do nothing but shoot pictures of your life. Start first thing in the morning and literally take pictures of all the things you see. If the first thing you see is the ceiling, take a picture of that. If it's your wife or husband, take a picture of her or him. Take pictures of your feet as you get out of bed in the morning, of your breakfast, of all the places you go and things you do. Don't be afraid to look a little crazy. Remember, this is not for making conventional photographs but to give you an intimate record of your daily life.

You don't have to go to exotic places to take exotic photographs. Here I photographed my foot in a shallow stream, using a slow shutter speed so that the sunlight on the water seems to move. With the most mundane ingredients you can make magic.

The sameness of the homes and automobiles is highlighted by the huge "have a nice day" face looming over the rooftops like a dada exclamation point. The humor in this photograph is unmistakable.

# Feelings

Photograph something or someone you feel very strongly about and show your feelings about that person or object in the picture. For example, you can turn your girlfriend or boyfriend into an angel by using soft lights and a fog filter. Or turn your landlord into a demon by using a flash from below his or her face. If you are afraid of dogs, you can take a series of scary photographs of your neighbor's German shepherd, catching the animal when it's leaping or growling. I once took two sets of photographs of smokestacks; in one series I shot them from below in bright sunlight, making them look like marble pillars; in the second series I shot them head on during a rainstorm, making them look like decaying tree trunks. In this exercise use everything you've learned about lighting and camera angle, plus all the other tricks covered in this book to achieve whatever emotional effects you want.

# New Ground

Photograph something you've never shot before. We are all creatures of habit and tend to repeat ourselves over and over again. This is also true of our picture-taking habits. So break new ground and cover something that is outside your normal pattern. Try a still life of the fruits on your kitchen table. Photograph a neighborhood you've never visited before. Try shooting pictures from your television screen. Go to a nearby park and shoot flowers and rocks, attempting to capture the random patterns in nature.

# Rediscovery

Photograph someone you see often but don't know very well. This could be your mailman or the woman who sells you the morning paper. Tell the person that you are studying portrait photography and would like to use them as a model. Use your camera to draw the person out, to get to know him or her better. Make it an experience of exploration. You'll be surprised at the quality of portraits you get. An added bonus is making new friends.

# People at Random

When you are traveling, see if you can get a picture of everyone you meet. This includes the waitresses, conductors, policemen, and strangers you speak to on the street. While each of these people might not seem to be too interesting a subject in isolation, when you put the series together you will find a fascinating study of human nature, not to mention a priceless record of all those familiar faces that contributed to making your trip so enjoyable.

# Double Exposure

You can't do this with cartridge-loading cameras, but with 35mm cameras a very interesting trick is to double expose the roll. After you have shot and rewound the film, run it through again. When you rewind it, though, make sure you leave a little bit outside the canister so the film can be pulled out again. It is a good idea to keep a log of what pictures you shot first time around so you can plan some of your photographs, superimposing a person's face on trees, an automobile in the middle of a lake, etc.

# Haystacks

The great French impressionist painter Claude Monet once painted the haystacks outside his window over a long period of time, with different weather conditions and under all kinds of light. He did this to train his eye and hand. You can do the same thing with a camera. Choose a single object and then photograph it under as many different conditions as possible. Change lighting, lenses, framing, focus, and any other variable you can.

---

There are actually many people on either side of this man, who is watching a parade. But by isolating him and the woman, and by eliminating any clues as to why he is standing on a pedestal, I have turned an ordinary event into a visual joke.

# Change Equipment

If you have a 110 and haven't used anything else for a year, take a 35mm or Instamatic along on your next shoot. If you only use cameras with manual controls, try an automatic, and vice versa. Our perceptions get limited by the technology we use, so don't get stuck looking through the same viewfinder all the time.

# Musical Cameras

When you are with your family or any group of people, pass the camera around. Let everyone take a few pictures. Not only will you get a wider variety of shots than if you had taken them all yourself, but you will also put people at ease and get far more candid photographs of them. This works especially well with children over the age of six.

# Narrative

Use your camera to tell a story. It could be something very simple, like your friend going out shopping. Shoot him or her at home, on the street, in the shops, and returning home to collapse on the sofa. Or you might take a sequence of your child opening a present. After a while you may get more ambitious and use your camera to make extended jokes. The idea here is to expand your sense of photography past the single frame and into the notion of a series.

# Figure Photography

Take pictures of nudes. Many people shy away from this because of embarrassment, but the nude is one of the classic subjects in art and you should try your hand at this kind of photography. Photograph your husband, wife, lover, or friend. Or, if anonymity will help you to be less shy with this kind of photography, hire a model. Whoever you work with, though, will require some direction from you.

Some important things to remember are: Make the surroundings comfortable; for example, in winter make sure there is enough heat. Have the person take his or her clothes off twenty minutes before the shoot to let any marks from clothing disappear. Tell the person to stretch, relax, and get loose. You can play music and have the subject dance, shooting as he or she moves.

Remember to keep a balance between the impact of the naked body and the abstract shapes it is capable of suggesting in different postures. Nudes can be wonderful in black-and-white, although color offers limitless possibilities since skin tones can be shown so realistically.

# Gallery

There is an artist named Ramon Muxter who has published a book of photographs of himself and famous people. The way he takes the photographs is to put one arm around the person's shoulders and take the picture with the camera held at arm's length in the other hand. You may not know many famous people, but you can certainly use this technique with your own friends and family. And since you are always shooting from the same distance and in the same pose, after a while you can see yourself as you change over time and in relation to all these people in your life.

# Fantasies

A friend of mine once had ten thousand dollars in cash. He wasn't rich, but it made him *feel* rich. And he wanted to act out a favorite fantasy of his, that of Scrooge McDuck taking baths in his money. He got all the money in small bills and then sat in a bathtub, throwing it up in the air and "bathing" in it while I took four rolls of film, both color and black-and-white. He has long since spent the money, but now has the photographs to remind him of the time he was rich. I don't know what your favorite fantasy is, but whatever it is, try to get it on film so you can share it with others and make it more real for yourself.

Sometimes patience and consistency are necessary to produce "spontaneous" effects. In this case I stood across the street and shot twenty people walking behind the pole until I captured precisely the right quality.

# Anarchy

Break all the rules. Go berserk with your camera for a few rolls. Shoot into the sun, tilt the camera, don't use fill-in flash, cut people's heads off in the viewfinder, shoot in poor light, try to get red eye. There are two reasons for doing this. The first is just to have fun. The second is that you will come up with some surprisingly interesting photographs, some of which are quite artistic even by the most conventional standards.

# ◙ TOY CAMERAS

In addition to breaking the rules of photography with the camera that you have, you can play with an entirely different kind of camera. There are two which are extremely cheap yet produce fascinating results and provide a real sense of creativity in taking pictures with them.

The first is the Diana. This is a very cheap (about two dollars, depending on where you buy it) plastic camera made in Japan. Intended as a toy, it has gathered some serious proponents in the United States. Many art photographers have used it, and there has even been a book of photographs taken with it entitled *The Diana Show* (see Bibliography).

Because the lens is made of such cheap plastic, the photographs come out with a dreamy, often distorted quality which, ironically, cannot be reproduced using the most expensive lenses and filters. Well-known photographer Nancy Rexroth describes her experiences with the Diana in this way: "The Diana is made for feelings. The Diana images are often like something you might faintly see in the background of a photograph. Strange fuzzy leaves, masses and forms, simplified doorways. Sometimes I feel as though I could step over the edge of the frame and walk into this unknown region."

Diana aficionados often buy six or seven of the cameras, searching for the one with the *worst* lens. The camera leaks light everywhere and it is necessary to put black tape over all edges and corners. You have to keep the lens cap on because even the lens leaks light!

The Diana takes 120 film and is certainly one of the most fun pieces of equipment you can own.

The second fun camera is the pinhole camera. This is nothing but the old *camera obscura,* or "dark chamber," which is the mother of all photography.

Making a pinhole camera is very simple, and there are books which go into complete detail (see Bibliography). There are many advantages. A pinhole camera is cheap. It promotes a reasonably good understanding of what photography is all about and so is ideal as an educational tool for children. You can get some highly unusual pictures with this kind of camera, as well as conventional ones. And, finally, you get the satisfaction of having made your own camera.

You can make a camera in a shoe box, a coffee can, a Quaker Oats box, or any other container, and get very interesting effects, including wide-angle and distortion.

Beyond all this, you can take pictures without even owning a camera, and that may be the most fun of all.

The first way of doing this is called *photograms*. A photogram is a shadowlike picture made by placing objects onto a light-sensitive paper and exposing the paper to a light source. All you need is sunlight, a subject, and photographic paper.

If you take a photogram in the sun, use a slow paper. Lay the paper in the direct light and place your objects on it. Let them stay there for almost two minutes. The paper under the subjects will stay white, while the parts exposed will turn dark purple. You will get sharp, often surreal-looking images.

You may also make photograms in your darkroom or in any darkened room. The technique is the same, only the light source and exposure time will be different.

Kodak Studio Proof Paper is good to use in sunlight, and Kodak Polycontrast Rapid Paper is good for indoors. Follow the directions on the box.

A second way to take photographs without a camera is to use a Xerox copying machine. This has come to be called "copy art." It is widespread among visual artists.

You can place anything you like on the glass of the copy machine, including parts of your body or objects or other photographs. They will come out differently than they would with a camera, but that is the point—to do something different.

If you take a photograph and make a Xerox copy of it, it will have a new texture, be more grainy, and portray a changed mood. If you copy the Xerox copy, you take it even further from the original. By the seventh or eighth copy, the photo will probably be unrecognizable as such, but a new work of art will have emerged, more abstract yet derived from a concrete original.

Obviously, xerography is not intended to be photography. But it is an interesting tool, and you can have fun with it beyond its intended purpose.

The third way to take photographs without owning your own camera is to use photo booths. These can be found in most bus, train, and airline terminals, most Woolworth stores, and all over the country. They are often used for passport IDs. They come in both color and black-and-white, and most cost about a dollar for four pictures.

But there is no reason to take dull photographs in these booths! You can take makeup, costumes, props, and backgrounds into the booth with you and have a ball, staging scenes and making faces at the camera. Photography should never be a burden or a chore to you. You should learn as much as possible about technical matters so you can use your equipment intelligently, but you shouldn't get preoccupied by that side of things.

When you go out with your camera, it should be with a light heart, a quick step, and a hunger for seeing and recording the world in individual and unique ways.

In the next chapter we'll talk about what to do with all the wonderful and not-so-wonderful photographs you have accumulated and how to display them to their full advantage.

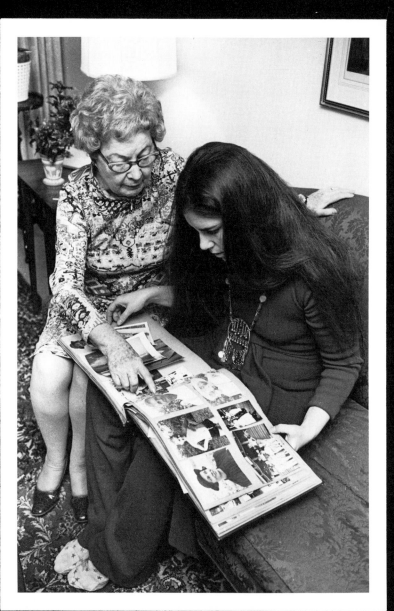

# Presenting Your Pictures

Whether you use a tiny pocket camera costing nineteen dollars or a bulky Hasselblad costing five thousand, they have one thing in common: You will have to wait for the developed photographs. The real joy of photography comes in holding the finished product in your hand, and the anticipation can be agonizing.

Once you have your pictures, you have to decide the best way of storing and displaying them. In the early days of the Kodak Brownie, most people kept their photos in a shoe box in the closet, to be taken out on rare occasions and looked at with the reverence reserved for precious items.

As photography became more popular, the photo album became the primary form of storing photographs. Then came color slides and the slide tray became a common storage place.

Now, with new technology, photographic display is as extraordinary as all other areas of photography.

The family snapshot album is an invaluable record of the faces and places of the past.

# ◘ THE ALBUM

There are many kinds of photo albums, each with various advantages and disadvantages, covering a wide price range (from $2.95 to over $25).

The most popular type currently is the album with self-adhesive pages and cling-plastic overlay. With these you can use any size photo up to the dimensions of the page. But you must leave space around the edges to let the cling-plastic adhere to the page surface.

The plastic keeps the photographs dust-free, but it can also make the photographs appear a bit dull. These albums are very convenient, but once full they can be quite bulky.

There are albums with slit corners on each page so you can slip in the photograph. Only one print size will fit in these slots, so the album may seem monotonous. However, you can see the photographs without any overlay, and this is a good way for displaying a series of shots (a party, a trip to the ocean, etc.).

You can also get albums with plain pages and stick the photographs on with tape or glue, but then the photos are difficult to remove or to rearrange. You can also use opaque or transparent self-adhesive corners. These allow flexibility in laying out the photographs on a page, but over time they tend to loosen.

When putting your album together, first plan it out. Arrange the photographs according to some logical sequence—time or subject matter—and then lay them out in a pleasing manner. Juggle them around until you get a layout that balances the photographs in a harmonious way. Space the photos out so the album won't look too cluttered. Mix print sizes and see how the various colors and shapes in the different photographs relate to each other.

Put little descriptive passages next to each photograph, giving the date, place, and a brief explanation of the circumstances. Years from now you will be very thankful you have made the notes. They add focus and detail to the photographic record of your life.

# SLIDES

Showing slides is perhaps the most dramatic way of exhibiting your photographs. They can be blown up to practically any size. In the mammoth concourse of Grand Central Terminal in Manhattan, for example, there is a slide that has been projected onto a screen twenty feet high and sixty feet long!

But for most of us, showing our slides means projecting them against a small screen or a wall in our living room. Projecting slides brings out their brilliant colors and sharp detail.

There is a wide variety of projectors available, from inexpensive, hand-operated models to more advanced types that time the frequency at which the slides are shown, focus automatically, and play an accompanying soundtrack.

The most important thing in showing slides is editing. Remember, don't bore your audience. Shots of Aunt Sally, who you think is cute, might not be interesting to someone who has never met Aunt Sally or eaten her rhubarb pie.

Also, remember that the people seeing the slides don't have the associations you do. A wide-angle landscape might bring to mind a fond memory of the day you spent there, but to another person it is just another landscape unless the picture itself is dramatic and compelling.

Be strict with yourself when putting your slide show together. Look at each picture carefully and ask yourself whether it has visual appeal, both in terms of content and in terms of color and composition. Try not to be sentimental.

The best way to store slides is in a slide tray. This is a drum that holds eighty or more slides. To show the slides, all you have to do is slip the drum onto the special head of a slide projector.

# 📷 DISPLAY

This involves keeping photographs permanently out in the open. There are many options.

It is a good idea to go to a professional for advice on the best way to exhibit a particular photograph. However, this can be expensive and also robs you of the fun of being as creative in displaying your pictures as you were in shooting them.

The simplest method for do-it-yourselfers is to use a self-adhesive polystyrene board which can be bought in photographic and art-supply stores. They are about a half inch thick, very light, and easy to trim with a razor blade.

A more ambitious display is using frames sold in kit form. These can be purchased with precut matte boards to add a professional-looking finish.

Frame your favorite family photos and display them creatively. here a fluorescent light for growing violets also illuminates the photos.

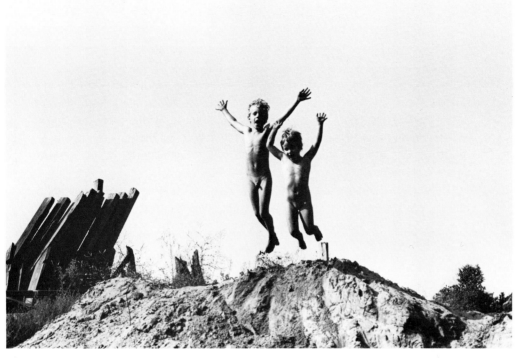

Family album snapshots of your children need not be dull and uninspired. Look for a fresh angle and a moment when the uninhibited exuberance of childhood shows itself. Lighten up and have fun!

There is a very wide variety of frames, from plastic overlays to wooden frames, and there are very ornate frames with silver or gold edges. There are double-sided photo frames for twin portraits and frames in all kinds of shapes, from hearts to futuristic designs.

No matter how you display your photographs, however, you should avoid placing them where they will be subjected to sunlight or even very bright daylight since this may fade the pictures. You can buy an aerosol spray which protects the ·film against ultraviolet rays. Follow the directions on the can.

For display prints I recommend the Cibachrome process, which is particularly resistant to fading. Any professional lab can tell you more about Cibachrome.

# ◼ UNUSUAL DISPLAY

With modern technology it has become possible to display photographs in ways unimaginable ten years ago. One of the most popular ways is on a T-shirt. Using special printing techniques, it is possible to have any picture mounted on a T-shirt.

It is also possible to have photographs printed on various other materials, so you can customize pillows, sheets, rugs, curtains, towels, etc. Of course, you should be careful not to flood your life with photographs, but there is always room for imagination.

Another possibility is making a poster. There are many ads in magazines for this. These posters can be very nice to give as presents, as well as decorating your own home. A commercial variation of these are the "panoramas." These are landscapes, seascapes, or cityscapes which are printed in very large sizes and glued to a wall without a window to give the impression that your apartment has a beautiful view.

You can turn your photographs into postcards. Special photographic paper is sold in the size and thickness of postcards. You just develop your print right onto the paper (the other side has spaces for address and message) and drop it in the mail. Don't forget the stamp!

You can do the same with greeting cards. Some have space for you to have your photograph printed, while others have slots for you to slip in your photograph.

There are also display cases that come in various shapes. There's the popular cube, which displays six photographs. Another is in the shape of a house which can display up to eight photographs in three different sizes.

A locket is one of the most traditional means of keeping and showing a picture—and still one of the most popular. If you don't think so, ask any teenager.

The most common form of commercial display, one which the amateur rarely thinks of, is reproduction through a commercial printing press. You can bring a photograph to a printer and have him run off a hundred or more copies more cheaply than you can have a hundred prints made. Actors do this when sending out résumés, but you might consider it for a bulk mailing —for example, to people who came to a wedding—or as Christmas cards.

One year my wife and I made our own Christmas card using a camera on a tripod, a self-timer, and a combination of window light and bounce flash. The hardest part was keeping eight cats on the table at once!

Show some imagination when displaying photographs. One artist had his black-and-white prints blown up to 8″ × 10″ size with a slightly larger border on one side. Then he pasted them back to back and had a binding company run a spiral spine down one side of the photographs. This gives him a one-of-a-kind book that is very precious.

You can put your photographs in unusual places. A New York photographer had a show called "Step On It" in which he displayed his photographs on the floor under Plexiglas. You literally walked over the pictures.

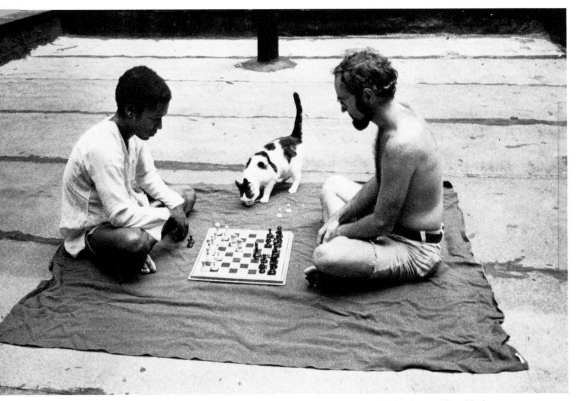

A black man plays the white pieces and a white man plays the black pieces while a black-and-white cat looks on. This deceptively simple photograph speaks volumes about race relations, friendship, and sport. I made a postcard of this photo.

When composing a photograph, my basic rule is: Keep it strong, keep it simple.

Backgrounds can tell a story. The man's bent posture in relationship to the huge steel wall speak of urban alienation and a downtrodden spirit. A close-up would not have been as effective as this panoramic view. For presentation purposes at an exhibition, I had a huge 40" x 60" enlargement made of this photograph. The resultant image, 5' long, had a tremendous impact that would have been lost in a smaller print.

Another good idea is to set up a large cork board, maybe 4′ × 8′, and use it only for photographs. This way you can live with your photographs, edit them, and see how you are progressing over time.

It is now possible to buy a special emulsion which you can paint onto just about any surface, thereby turning that surface into a photosensitive material. Thus, you can print photographs on eggshells, on pieces of furniture, on the very surface of the wall itself. Be advised, however, that this material may be difficult to remove.

These are some of the ordinary and fanciful ways of displaying photographs right now. The future, however, is limitless.

# The Future

As I indicated at the very beginning of this book, the future is here and it's happening every day. Technology is advancing with ever-increasing momentum in all areas of human life, and the effect upon photography is sometimes mind-boggling.

It took several hundred years to advance from the *camera obscura* to the first camera to actually *record* an image. It took only fifty years before emulsion techniques had become sophisticated enough to allow average people to take pictures that previously only specialists could handle. From there, only thirty years passed before the introduction of the first portable camera, the 35mm. And then, suddenly, at the end of the Second World War, the whole field broke wide open, leading to, among other things, the pocket camera.

Before long photography had become one of our major means of exploring the universe. Scientists were taking pictures of molecules and galaxies, and artists were breaking new ground in subject matter and technique. Equipment was streamlined and made inexpensively so that in the United States today there is hardly anyone too poor, young or old, to own at least one small, cheap pocket camera.

Behind all this is an army of men and women, chemists and engineers, who have dedicated their lives to the continual improvement of photographic film and equipment. This research is a painstaking task. Years may go by with only gradual progress on a project, and then, suddenly, a major breakthrough will happen. Imagine the celebration in the laboratory the day that the Polaroid process was finally perfected.

Pentax Auto 110
This illustrates how sophisticated the microcircuits must be in a camera in order to incorporate advanced features in a small body.

One of the recent innovations that set the world of photography on its ear is holography. Unlike photographs, holograms are not made with a camera and lens. A sensitized plate is used. This is developed and fixed, but it shows no image on its surface. Instead, the plate contains a record of the light pattern given off by the subject. If you then transmit laser light through the plate, the original light waves are reconstructed and a virtual image is seen where the subject once stood. Some of these images can only be viewed at 180°, but with other holograms you can walk entirely around the image and see the complete three-dimensional object.

Until recently holography was something only scientists dabbled with. Now it is becoming more popular. For example, in the Haunted House in Disney World, a ghostly head of a fortune-teller appears inside a crystal ball. You think it's a photograph at first, but as you move around the ball you can see the sides and back of the head as well. For an instant a chill runs down your spine as you insanely imagine it might be the head of a real person! And then you see a sign informing you that this is a hologram.

In 1975 the International Center for Photography in New York City rounded up some fifty holograms made by a group of scientists and artists. Currently there are plans for holography galleries in several major cities, and most quality bookstores now carry how-to manuals on amateur holography.

But while holograms won't be as common as Polaroids for many years to come, there is already a 3-D camera being test-marketed by the Nimslo Corporation.

3-D movies enjoyed popularity in the 1950s, but because looking at them involved putting on those silly red-and-green eyeglasses, nothing much came of them. But with the "Nimslo 3-D" you will get back actual three-dimensional prints from the developer—and you don't need special glasses to look at them. Such prints have been used for the famous "winking eye" and "weeping Jesus" novelty cards.

The camera itself has four lenses arranged horizontally in a single line. It is about the size of a regular 35mm pocket camera, uses standard 35mm color negative film, needs no focusing, features an automatic-exposure system. Surprisingly, this camera is in the medium price range.

But a roll of, say, Kodacolor film with thirty-six exposures will produce only eighteen pictures. That's because the camera's four lenses simultaneously produce four half-frame images from four different viewpoints. The Nimslo technique is to reassemble the scene to create a 3-D picture.

**Three Mamiya Compacts**
The Mamiya U is an ultracompact, lightweight 35mm camera which electronically selects its own shutter speed and aperture. Focus is selected from one of four zone-focusing symbols. It comes with a pop-up flash and has an integral dust cover-eyepiece blinds to protect the lens and viewfinder from dust and scratches.

The 135 AF is an almost foolproof camera, featuring AutoFocus, Auto Exposure and AutoFlash — all in a compact, lightweight unit.

The 135 EF offers many of the same features as the 135 AF, but uses a four zone-focusing system. A bright-frame viewfinder lets the photographer know when the subject is properly framed and in focus.

Advances in film technology have been keeping pace with changes in other areas of photography. The photographic industry has to improve its film across a broad range of fronts. Films are needed for weekend snapshooters as well as for a number of medical, technical, and other applications. And so scientists must work on all aspects of film sensitivity and quality. One indication of how far we have advanced can be see in the fact that from the earliest primitive photographs to modern ultrasensitive film, film speeds have increased more than 23 million times!

One advance is from Ilford, a British company now offering its HP5 72 exposure Autowinder Film. Because this company has developed a thinner emulsion, it can put twice as much film in a cartridge, which means that you can now get seventy-two exposures on a standard 35mm cassette.

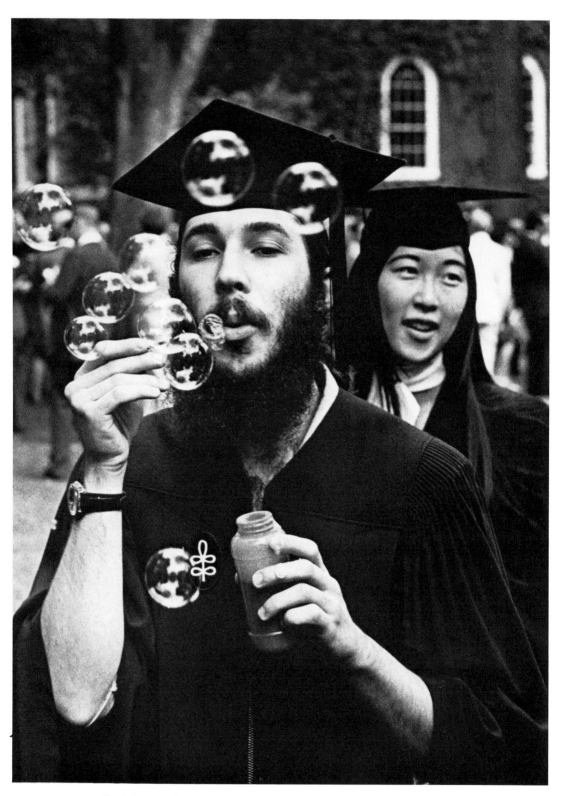

The dictionary defines graduation as "receiving a diploma from a school." But your photographs don't have to be that dry. Wander around and catch offbeat moments.

Because I was carrying a camera with automatic controls, I was able to capture this shot quickly as I was going up an escalator. This is the kind of picture that a professional would spend a long time figuring out in terms of proper lighting and focus. Remember that a simple camera doesn't necessarily mean simple photographs.

The same company has come up with an even more startling innovation, the XP1 film. It is a radically new black-and-white film that has almost miraculous qualities. Here are some of its features.

• You can shoot at a standard 400 ASA and get the same quality previously only available on slower films. This means that you can shoot at high speeds in low light conditions and achieve the image perfection and grain of a 100 ASA film. The negatives have such expanded range that your prints will capture far more detail in both shadows and highlights without fancy tricks in the darkroom.

• Unlike conventional black-and-white film, this actually produces a finer grain when overexposed! You can overexpose Ilford XP1-400 as much as 2 f-stops and achieve virtually grain-free images.

• Remarkably, you can begin to shoot at 400 ASA and then switch to 100, 800, or 1600 ASA right in the middle of the roll.

There are many other extraordinary features to this film, the implications of which have not yet even begun to be realized by photographers. And we can expect other companies to be manufacturing similar film. Agfapan Vario-XL is Agfa's contribution in this area.

The Japanese, as always, have taken the whole subject of film to a different level altogether by introducing a camera that doesn't use film at all!

This photograph shows the advantages and disadvantages of autofocus and automatic exposure control. The subject is not critically sharp — note the fuzzy focus on his left hand — yet the system did a good job of averaging the bright background and dark skin tones. Most importantly, the mood of exuberance is captured, which is always more satisfying than getting a technically accurate picture with no human feeling.

Sony's new filmless camera, the Movica, is about the same size and weight as conventional 35mm models, but instead of recording images on film a small magnetic videodisk is employed. An image that comes through the lens is converted into electronic signals by a special device. The disk holds fifty color pictures and can be *viewed instantly on a home color TV screen.* The image can also be transmitted over telephone wires!

How far can all of this go? It is impossible to tell. In a recent New York *Times* article on the future, it was pointed out that President Franklin Delano Roosevelt called together a brain trust in 1940 to predict changes in the following decade. They foresaw some things, but they missed a few, such as nuclear power, the impact of TV, the use of rocket propulsion, and the Communist revolution in China!

So it would be silly for anyone to try to predict what kind of break-throughs are coming, especially in a time when technology is advancing by leaps and bounds. Perhaps we might look to science fiction, which has predicted so many things, beginning with Jules Verne, who foresaw the airplane.

An amusing notion was put forward by David Eisendrath in the photography magazine *ASMP at 35*. He states, "Fourteen years ago I wrote about equipment of the future: cameras that give correct exposure, cameras that focus automatically, and cameras that advance and rewind film automatically. Of course, *that* future is now. But I ended by predicting the time would come when the ultimate camera for the amateur incorporates a *motif finder*."

A motif is either a unifying theme, idea, or pattern. The vision of a camera that is programed to "think" abstractly seems totally absurd. But there is much truth in humorous speculation, for that is where the imagination is freest.

Eisendrath concludes, "When a motif appears in front of the lens, a light appears on the camera and the photographer is then confronted with the final conclusive decision: should he press the button and preserve the scene for posterity, or should he quench it? Don't laugh, it may come!"

Not only am I not laughing, but I can see a time when the photographer will not be necessary at all. When the camera sees the proper motif, it will just press its own button.

If we remember that most of the photos taken in outer space were done by robots, we can even fantasize a camera that gets up, walks outside, takes photographs, and returns to its owners like a dog bringing back a stick.

We are living in an age when the line between fact and whimsy is very thin. But no matter what specific changes take place in photography, one thing is certain: We will see a treasure chest of innovations that will make the fascinating and highly personal art and craft of photography ever more pleasurable and gratifying.

So, with that in mind, pick up your pocket camera and begin to see the world in an entirely new way!

# Selected Bibliography

1. Bruce, Helen Finn. *Your Guide to Photography*. Harper & Row, New York, N.Y., 1974.

2. Burk, Tom. *How to Photograph Weddings, Groups and Ceremonies*. HP Books, New York, N.Y., 1980.

3. Busselle, Michael. *How to Take Better Pictures*. Crescent Books, New York, N.Y., 1981.

4. Curtin, Dennis. *Your Automatic Camera*. Curtin & London, Somerville, Mass., 1981.

5. Feininger, Andreas. *Light and Lighting in Photography*. Amphoto, New York, N.Y., 1976.

6. Flatherstorm, David, ed. *The Diana Show: Pictures through a plastic lens*. Friends of Photography, Carmel, Calif., 1980.

7. Gatewood, Charles. *People in Focus*. Amphoto, New York, N.Y., 1977.

8. Glashow, J.; Goldstein, D.; and Mahler, S. *Shoot the Works*. Ziff-Davis Books, New York, N.Y., 1981.

9. Hattersley, Ralph. *Beginner's Guide to Photography*. Doubleday & Company, Garden City, N.Y., 1970.

10. Hedgecoe, John. *Complete Course in Photographing Children*. Simon & Schuster, New York, N.Y., 1980.

11. Kodak. *The Joy of Photography*. Eastman Kodak Company, Rochester, N.Y., 1979.

12. ———. *The Kodak Guide to 35mm Photography.* Eastman Kodak Company, Rochester, N.Y., 1981.

13. Langford, Michael. *Basic Photography.* Focal Press, New York, N.Y., 1977.

14. ———. *The Pocket Camera Handbook.* Alfred A. Knopf, New York, N.Y., 1980.

15. ———. *The Instant Picture Handbook.* Alfred A. Knopf, New York, N.Y., 1981.

16. London, Barbara, and Boyer, Richard. *Photographing Outdoors with Your Automatic Camera.* Curtin & London, Somerville, Mass., 1981.

17. ———. *Photographing Indoors with Your Automatic Camera.* Curtin & London, Somerville, Mass., 1981.

18. Purcell, Carl. *Complete Guide to Travel Photography.* Ziff-Davis Books, New York, N.Y., 1981.

19. Shull, Jim. *The Hole Thing: A Manual of Pinhole Photography.* Morgan & Morgan, Dobbs Ferry, N.Y., 1974.

20. Steichen, Edward, comp. *Family of Man* [ed. Jerry Mason]. Museum of Modern Art, New York, N.Y., 1955.

21. Vestal, David. *The Craft of Photography.* Harper & Row, New York, N.Y., 1975.